KINDRED SPIRITS

THE ELOQUENCE OF FUNCTION

IN AMERICAN SHAKER AND JAPANESE ARTS OF DAILY LIFE

A TRAVELING EXHIBITION ORGANIZED BY

MINGEI INTERNATIONAL
MUSEUM OF WORLD FOLK ART

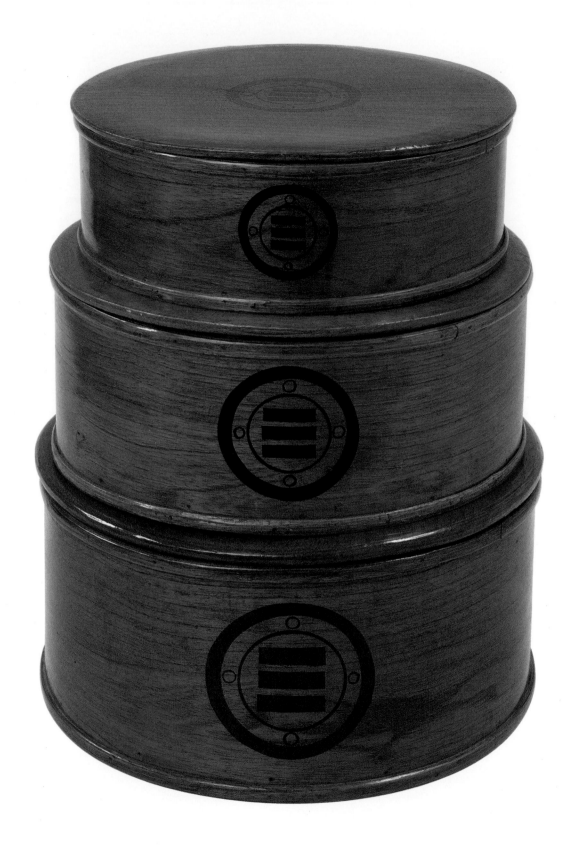

NESTED ROUND BENTWOOD BOXES–Cedar (*sugi*), laquer. Large box: 17.5 x 36.5 cm

Okinawa, Late Meiji Period, 1890–1910. The Peabody Essex Museum, Salem, MA

2

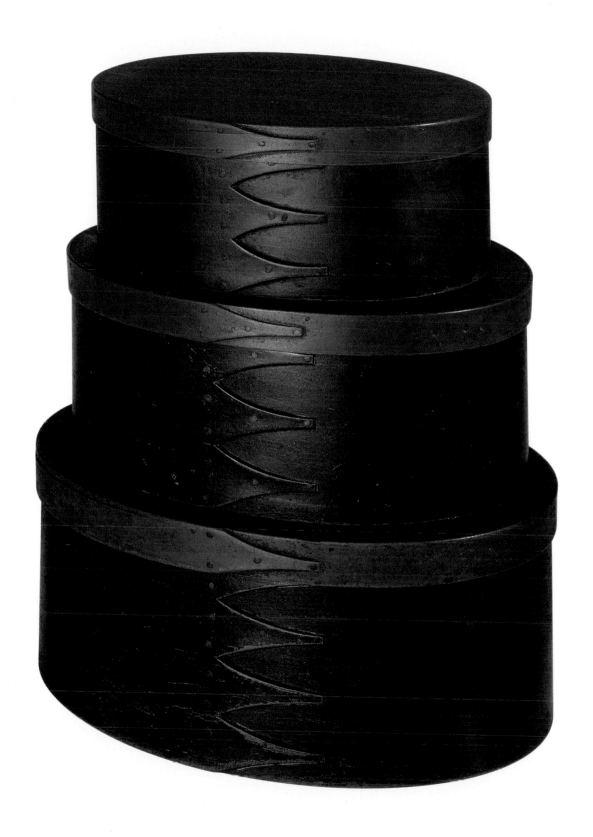

NESTED OVAL BENTWOOD BOXES - Sugar maple, white pine, paint, copper fastenings.
Large box: 13.9 x 34.3 x 21.1 New Lebanon, NY c. 1830-1850. Hancock Shaker Village.

KINDRED SPIRITS

THE ELOQUENCE OF FUNCTION

IN AMERICAN SHAKER AND JAPANESE ARTS OF DAILY LIFE

The exhibition, including its related public programs and national tour, is organized by MINGEI INTERNATIONAL MUSEUM OF WORLD FOLK ART

and is made possible by a major grant from THE LILA WALLACE-READER'S DIGEST FUND

This documentary exhibition publication is funded by A GRANT FROM THE JAPAN FOUNDATION

A GRANT FROM JOANNE AND FRANK WARREN

Additional funding is provided by the Publication Funds of SEYMOUR E. CLONICK AND SYDNEY MARTIN ROTH

Library of Congress Catalog Card Number 95 - 76069
Published by Mingei International

University Towne Centre, 4405 La Jolla Village Drive, San Diego, CA 92122
(Mailing address: P.O. Box 553, La Jolla, CA 92038)

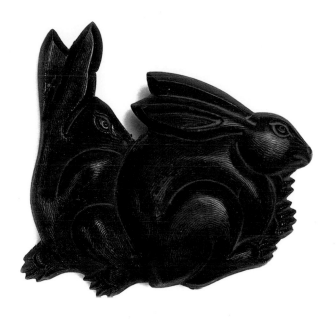

MINGEI INTERNATIONAL MUSEUM OF WORLD FOLK ART

San Diego, California April 21, 1995 - October 8, 1995

THE MORIKAMI MUSEUM AND JAPANESE GARDENS

Delray Beach, Florida November 14, 1995 - March 3, 1996

THE ART COMPLEX MUSEUM

Duxbury, Massachusetts April 12, 1996 - September 8, 1996

This exhibition is based on a major loan from

HANCOCK SHAKER VILLAGE

In Pittsfield, Massachusetts, U.S.A.

ACKNOWLEDGEMENTS

THE BOARD OF DIRECTORS OF MINGEI INTERNATIONAL MUSEUM GRATEFULLY ACKNOWLEDGES THE CONTRIBUTIONS OF THE GUEST CURATOR, WILLIAM THRASHER, THE SPONSORS, MUSEUM DIRECTORS AND STAFF OF THE LENDING INSTITUTIONS AS WELL AS OTHERS WHO HAVE HELPED MAKE POSSIBLE THIS DOCUMENTARY PUBLICATION.

Lending Institutions

AKARI ASSOCIATES – ISAMU NOGUCHI MUSEUM AND FOUNDATION
THE ART COMPLEX MUSEUM
THE BROOKLYN MUSEUM
THE FRUITLANDS MUSEUMS
HANCOCK SHAKER VILLAGE
KITAMAESEN MUSEUM AND THE KAGA CITY BOARD OF EDUCATION
MINGEI INTERNATIONAL MUSEUM OF WORLD FOLK ART
MINGEIKAN (The Japan Folk Crafts Museum), Tokyo
THE PEABODY ESSEX MUSEUM
THE WESTERN RESERVE HISTORICAL SOCIETY AND LIBRARY

Private Lenders

MILLICENT AND HERBERT BRILL
DON CARPENTIER
PAUL DIXON
JUDITH DOWLING, Edo Gallery
ISAMU KAWAGUCHI
GERRIE KENNEDY
TATSUO MATSUDA
SHIIKO SUZUKI MORIHISA
MIRA NAKASHIMA-YARNALL
KIYOSHI OTA
TIMOTHY RIEMAN
SHAKER WORKSHOPS, Concord, MA
SHIGERU SHINOMIYA
YASUHIDE SUNAMURA & LAUREN PEARLMAN, Sanpho Gallery
HEIJI SUZUKI
CATHERINE AND LENNOX TIERNEY
MANJU UESUGI
JOHN AND ANN WEAVER
DAI WILLIAMS
SORI YANAGI

CONTENTS

Japanese Ornamental Bronze Nail Cover – Rabbits | 5
6.5 x 1.5 cm. The Peabody Essex Museum E20,352

A Present from the Natives brought by one of Father Issachar's Tribe

Step forward now With courage new. Thy works are good. Thy faith is true.

A Breast-plate from Holy Mother.

A leaf of sweet-water

Hearken, dear child, to the voice of Wisdom. I have paved thy path with sweet-smelling flowers & thy wayside with pleasant fruits. I placed thee with my own hand in the heart of my Zion upon earth. So be ready and prepared; for when my time doth come I shall call thee to be a light-& reflt to other souls. For I have a place allotted for thee, which thou shalt fill in the beauty of holiness.

Wings of holy power, from Fr. Issachar.

Fruit of selfdenial

A Dove from Mother Ann.

A Crown of bright glory, From Father William.

A Cup of Holy Water, From Father James.

Joanna Kitchell.

Nov. 10th 1848

A Dish of Fruit from The Native Spirits. With their kind love.

COLORED INK GIFT DRAWING -- A PRESENT FROM HOLY MOTHER TO BROTHER JOHN C. BROT BY HER LITTLE DOVE

Polly Ann (Jane) Reed, New Lebanon, NY. September 7, 1848. The Western Reserve Historical Society, Manuscript Library, Cleveland, OH. Ex Cathcart Collection

Prologue by June Sprigg

The Fifteenth Rock: On Shaker Design

When I was a very little girl in California, I fell in love with Japanese things in a shop around the corner—with cool, dark, river-polished pebbles, with a doll no bigger than my thumb with a white plaster face and red brocade kimono, with the small packing boxes themselves, made of light, scented sandalwood. When we moved East, my interest in Japanese things grew as I did, with books and visits to other shops and museums.

I was nineteen when I met the Shakers in New England and discovered that I felt the same pleasure in Shaker things—in rows of tiny red spools on a yellow base, in oval boxes with lids that slipped on and off so smoothly that the air in them sighed, in a kitchen cupboard made of pine without knots, stained bittersweet, with apple-wood pulls.

These paths began to converge for me as an adult. In the work of Soetsu Yanagi, especially *The Unknown Craftsman,* I found ideas that seemed to me to speak of the Shaker as well as the Japanese insight into beauty. In my personal life I began to find light by which to travel in the teachings of Buddha and Christ. Finally, in my first visit to Japan in 1992, I visited the Japan Folk Crafts Museum in Tokyo while overseeing the installation of the first major exhibition of Shaker design in Japan in the Sezon Museum of Art. During my walk through the galleries, when I was deeply honored to meet Soetsu Yanagi's son, Sori, I felt that I had come home. I did not feel like a stranger in a strange land.

My role in this exhibition, *KINDRED SPIRITS – The Eloquence of*

Function in American Shaker and Japanese Arts of Daily Life, which brings together examples of Shaker and Japanese craft, is to write about Shaker design. If we are to understand what the Shakers made, we must first understand something of their life and what they valued. It was my good fortune to live and work with the Shakers in New Hampshire for most of three years in the early 1970s. What I have learned comes from those years and the subsequent twenty years of friendship with the living Shakers and my own and others' research into the Shakers' past.

The Shakers, or United Society of Believers in the First and Second Appearance of Christ, were a communal, celibate, monastic Protestant society who flourished in America in the late eighteenth and nineteenth centuries. The Believers sought to place the good of the group above the desires of the self and spent their lives humbling their wills obediently to the instruction of the Bible, their English founder Mother Ann Lee (1736-1784), and the leaders of their communal settlements.

As a community of seekers after salvation, they were most deeply interested in the spiritual life. But they also believed that the "natural" world perceivable by our five physical senses was an emblem or reflection of the real but intangible spirit realm perceivable to the spiritual senses. I am not sure that the Shakers believed that the material world was not "real." But I know that they believed in the absolute reality of the spirit world, which they recognized as more enduring and more true somehow than this worldly existence which is bound by and limited to the laws of space, matter and time.

The Shakers' attitude about material possessions may at first seem contradictory to Western minds. On one hand, the Shakers felt a

desire to free themselves from what was not essential. In their understanding, this meant freedom from an excess of possessions and also the elimination of ornament, which they considered superfluous. On the other hand, the Shakers cared very much about the appearance of their things precisely because they were felt to reveal the spiritual values that mattered deeply. As a group, the Shakers loved usefulness, simplicity, cleanliness, and order in everything given to them by God, which they believed to be everything, indeed, from their chairs to their souls.

Humility—perhaps the single most important requirement of a successful Shaker life, was also evident in their work. Shaker artisans used ordinary materials—stone, iron, wool, linen and local woods like pine, cherry, and butternut, to make utensils for everyday, household use—pails, boxes, furniture, bedding, clothing, brooms, and tools. The workers were taught to be humble themselves and to bear in mind that all talents were gifts from God. One could enjoy one's work, but not exult in the pride of making or of ownership. Individual Shakers were discouraged from signing their works and did not privately own what they made or used. They repeated the words of their spiritual Mother: "Do your work as though you had a thousand years to live, and as if you were to die tomorrow"; and "Put your hands to work and your hearts to God, and a blessing will attend you." Shaker craftsmen and craftswomen were famous in America and as far away as England for the high quality of their products; the Brothers and Sisters who served as business agents were equally well regarded for their integrity.

If the Shakers had cared little for the tangible appearance of their villages and homes, they would have made do with whatever useful items would have come their way through donation by converts, as, indeed, they did in their first decades of organization and poverty.

Instead, they devoted themselves to building and furnishing dwellings and workshops with great care for the way things looked. That kind of caring costs time and money, which most of us know firsthand. Faced at present with the happy chore of choosing and furnishing a home to accommodate our newly combined family, my husband and I are reminded daily that wanting things to look any particular way–even Shaker simple, requires significantly more time and money than not caring about how the house looks.

What I am able to explain about Shaker design includes the qualities of restraint, simplicity, utility, order, and excellence, all of which you can see for yourself in the objects in this exhibition. The why of Shaker design, however, remains beyond my power to explain. The work of Shaker hands bespeaks to me a serene mindfulness of the right place of things in the universe and a blend of dream and discipline that allowed the makers to create in earthly materials–perhaps re-create is a better word, something of an imagined ideal. I can catch only glimpses of the sacred passion and joy that underlie the subtle color, the graceful line, the elegant proportions.

The Shakers, who have been in the world for only a little over two hundred years, have probably numbered no more than ten thousand in their entire history. What was there in this brief flicker of existence that led these people to create work that impresses observers worldwide with its simple grace? I used to imagine that I had to know the answer to that question. I have come to believe that experiencing the pleasure of Shaker things is more important than attempting explanations. The Shakers I knew kept it simple. They cherished and admired the work of their predecessors, whom they called the old Shakers, with reverence and affection, because they saw in it the love of God and the way of Christ.

When I consider Shaker design now, I think of the dry Zen garden of Ryooan-ji in Kyoto–fifteen rocks placed in a sea of raked gravel by a monk some 500 hundred years ago. It seems utterly straightforward, until we learn that one of the rocks is always concealed by another from our point of view as we circle the plot, no matter where we stand. Those who would see all fifteen rocks must free themselves from the bonds of this world and the limitations of time and space. I think that Hannah Cohoon, the Shaker Sister and vision artist who painted "The Tree of Life" bowing and blowing in the celestial wind of the realm of the spirit, would have understood clearly what I see though a glass darkly.

Today, the paths of Shaker and Japan have come full circle. The exhibition, KINDRED SPIRITS – The Eloquence of Function in American Shaker and Japanese Arts of Daily Life, has opened in San Diego within a few miles of where I first encountered Japanese things. Now, almost forty years later, I see more of the way along which I have been led: from California to the East, further east to Japan, and east yet further back to where I began in the West. The ocean that I played in as a child laps at all our shores. That guest curator, William Thrasher, and the staff of the Mingei International Museum of World Folk Art perceived a kindred spirit in Japanese and Shaker craft does not surprise me. May you share my delight in this exhibition.

June Sprigg (Mrs. James E. Tooley) has written about the Shakers for the past twenty years. She has served as guest curator for exhibitions at the Whitney Museum of American Art and the Corcoran Gallery of Art, and as co-curator for exhibitions at the Museum of Fine Arts in Boston and the Sezon Museum of Art, Tokyo. She lives in the Massachusetts Berkshires with her husband and his children, Jeff, Phil and Jill.

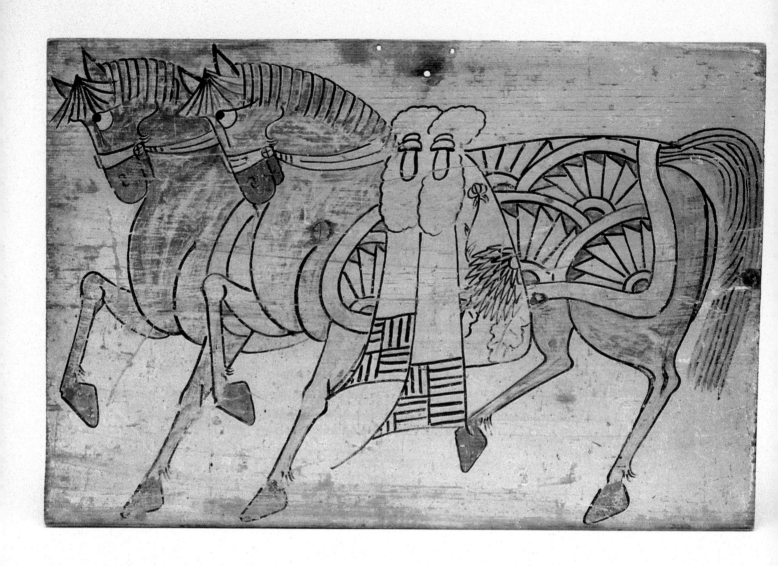

EMA – VOTIVE PAINTING – Cryptomeria *(sugi)*. 28.4 x 43.1. Late Edo to Early Meiji Periods. Mingei International Museum. Votive Paintings of horses were made as substitutes for live horses offered long ago at large shrines for the Shinto *(Kami)* gods to ride. *E* is Japanese for a "painting" or "picture," and *ma* in this use means "horse."

Forward by Martha W. Longenecker

Founder and Director – Mingei International Museum of World Folk Art

Within the pages of this book is an opportunity to look quietly at many different arts of daily life created by men and women to fulfill essential needs. Their strong, simplified forms are the flowering of living traditions of order – order rooted in both the East and the West. Within the contrasting cultures, similarities between American Shaker and Japanese arts of daily life have often been observed and noted, as in *Tansu* by authors Ty and Kiyoko Heineken.

"Both the belief in an inherent spirit in each object and the Shinto emphasis on purity contributed toward a unique aesthetic that utilizes space and materials most effectively. This aesthetic is evident in every facet of Japanese culture, and it is especially prominent in traditional architecture

"In a similar quest for purity, the Bauhaus in the 1920s postulated the design precept 'less is more,' approximately one thousand years after Japan had developed a similar aesthetic. Perhaps even more closely analogous to the Japanese experience than the Bauhaus are the Shaker communal experiments of the nineteenth century. Although the strict religious tenets of the Shakers may not be relevant, their glorification of God through the effective utilization of time and resources developed into a Western aesthetic based upon purity in some ways strikingly similar to that of the Japanese.

"A comparison of cabinetry reveals that, for both the Japanese craftsmen and the Shakers, form was primarily determined by function. Simplicity, balance, utility, and durability are common characteristics. In their specific approaches to materials and techniques, both cultures relied upon local woods, avoided decorative joinery, and shunned veneers in favor of the honesty of solid woods. In

terms of utilization, the Shaker tendency to build case pieces into the room structure, use structural 'dead space' for storage, and leave floor space open is paralleled in the nineteenth century only in Japan." [1]

By the early twentieth century industrialization in America had strongly affected and diminished Shaker hand production of furniture, textiles and all manner of eloquent objects produced for daily use. During that same time period the revered scholar of Japan, the late Dr. Soetsu Yanagi, was residing in America and lecturing on Japanese art history at Harvard University. He observed that many articles made by unknown craftsmen of pre-industrialized times were of a beauty seldom equalled by artists of modern societies. He recognized that unsurpassed beauty was the flowering of a unified expression when there is no division of head, heart and hands and that, with the increasing mechanization of society, few people perform an act of total attention.

During the early industrialization of Japan, Dr. Yanagi awakened people to their essential need to continue making and using handmade objects which express the whole being. He coined a special word for arts of the people–mingei, which combined the Japanese words for people *(min)* and art *(gei)*. With the potters Shoji Hamada and Kanjiro Kawai he founded the Mingei Association and in 1936 established in Tokyo the first folk craft museum of Japan. Through their work living art traditions of Japan that had endured unbroken for thousands of years were not lost to present and future generations.

Many of the contemporary craftsmen who were nurtured by Yanagi's teaching became Living National Treasurer of Japan, their work possessing qualities of naturalness and beauty akin to that of the unknown craftsmen of prior days. Notable examples represented in this publication are the pottery of the late Shoji Hamada and the stencil dye designs of the late Keisuke Serizawa.

Today Sori Yanagi, son of the founder, directs The Japan Folk Crafts Museum and continues the visionary leadership. His direction is expressed in the following excerpts from his writings.

"In the words of Soetsu, the beauty of folk crafts is the beauty of 'naturalness and health.' It is not created by conscious intent, but is spontaneous, unconscious, and vigorous, arising out of devotion to function.

"William Morris, the nineteenth-century champion of craftsmanship, said, 'Healthy beauty resides in a healthy society.' Things reflect the society that made them. For beautiful things to be made, not only the makers but the users and the entire distribution network between must be healthy. That so many products of the Edo period (1600-1868) are beautiful is a sign of the general health of the age. At the same time, there was, I believe, a special rapport or *gemeinschaft* between users and makers.

"As an industrial designer, I believe in principle that it is possible to create machine-made products, even tableware and furniture, no less beautiful than those of the age of handcrafted work. And yet there is something in the cultural products of societies where handcraft is a way of life that modern designers cannot match. The magical, raw power of African masks, for example, is beyond the reach of modern city dwellers. In Tibet, men and women call loudly back and forth from atop high peaks, their voices resounding beautifully amid the encircling mountains in a musical dialogue of love. In Mexico, as women thresh wheat with their bare feet, along comes an old man who fashions reeds into a rough flute and begins to play, the women quickly picking up the rhythm with their footsteps. The sound is not polished but earthy, as if it arose from the very soil. This sense of human warmth, born out of daily life and experience, wrung out of the depths of human existence, is missing in modern design.

"I believe that beauty is inseparable from *yo*, meaning function or use. *Yo*, in the sense that Soetsu used it, is broader in scope than the functionalism and practicality of which modern designers speak. It is a word that embraces the mental or spiritual dimensions of human life. What startles us today when we look at older folk crafts is the sense of the wellspring of human life that lies within them, from which an innate beauty rises.

. . . . "Simply because handmade goods may be beautiful, however, it does not follow that we can or should turn out identical goods on machines. Now that the vast majority of everyday items is machine made, the thing to do is not to insist on a return to the past, but to look to improvements in machine production as the keys to the future. To draw out the spirit of folk crafts and give it substance within the context of our modern, changing environment is the way to carry on the tradition of Japanese mingei in the present, and to provide direction for the future." [2]

Sori Yanagi's words reinforce the saying that seems so relevant to the exhibition and publication, *Kindred Spirits* - "Tread not in the footsteps of the past, but seek what they sought."

Inspired by the work of Dr. Yanagi, Mingei International – Museum of World Folk Art continues to further the understanding of arts of the people (mingei) from all cultures of the world.

1 Ty & Kiyoko Heineken, *Tansu, Traditional Japanese Cabinetry*, Weatherhill, New
 York, 1981, pp. 1-3. Printed with permission.
2 Japan Folk Crafts Museum, *Mingei – Masterpieces of Japanese Folkcraft*,
 Kodansha International, Tokyo, New York, London, 1991, pp. 31-32.
 Printed with permission.

Commentary by William Thrasher, Guest Curator

The believer worked patiently, lovingly, earnestly, until his spirit was satisfied that the work was "just right." Fidelity to the demands of the workman-like conscience was a fundamental act of worship. Through fidelity, the workman became an instrument of God's loving care for the community. His work was therefore fruit of the Shaker Covenant. . . . [1]

Thomas Merton
from Religion in Wood: A Book of Shaker Furniture

. . . The labor of Japanese craftsmen in making things provided in itself the reaffirmation of existence. . . . Tools could become one with and inseparable from the craftsman, it was thought, and this led to the idea of the personification of tools. . . . This view of the meaning of work and of tools is still very much alive in Japan today. Contemporary Japanese feel the presence of the divine–the invisible realm of the anima–in every part of the creative process. [2]

Mitsukuni Yoshida
Tsu Ku Ru: Aesthetics at Work

I have often envisioned this exhibition without a single word of commentary: objects alone, with no dates, no provenance, no information other than what the objects alone provide. Still, such an experience is possible; one need only ignore the descriptive captions. However, because this exhibition focuses attention on utilitarian objects, most of which were used in daily life, I will try to provide a basic framework for understanding them for what they are, some far removed from the people and the time in which they were produced. Ultimately, the objects speak for themselves. As George Steiner says, "The best readings of art are art."[3]

These are materials of culture that come from two distinct groups whose lives are unfamiliar to most people, with patterns of living

very different from those of today. Relatively few people now make baskets, spin fibers and weave textiles out of pure necessity. It is, therefore, important to remember that most of the objects in this exhibition are things that were made because people needed them.

Consequently, this exhibition is first about objects made by hand. Some, such as the Shaker broom, are so quiet and simple that were they not singled out, they might go unnoticed. Others, like the Shaker ribbon maple case of drawers and the Japanese painted fireman's coat, are so intricate and elaborate that it is difficult to envision them in an ordinary setting. A few, such as the Shaker quilted red velvet bonnet or the Japanese black lacquer water container for tea ceremony, are unusual pieces for special occasions.

Among the two hundred exhibition objects, half are American Shaker and half Japanese; and they reflect roughly the same period of time, 1800-1995. The two groups represented by these objects share no cultural or racial roots; and it is unlikely that, until recently, one group has known directly much about the other.

Yet such extremes of culture often touch in curious and surprising ways. In my study of Shaker and Japanese cultural materials I discovered that it is not the precise physical similarities of form or use of objects that interest me as much as the similar attitudes of the people toward the work of human hands, standards of excellence and spiritual orientations toward time or the use of natural materials. The selection, therefore, is not a comparison of forms.

Primary considerations in the research and selection of objects for this exhibition have been designs and constructions unique to or

characteristic of Shaker and Japanese artisans. A second criterion has been the distinctive eloquence of function when an object has been made "just right," as Thomas Merton said. The eloquence of function is only fully realized by the user.

It is worth remembering that many pieces are the result of a collaboration of two or more artisans and often with laborers: wood or bamboo had to be cut, cured, and prepared into workable materials; and in particular crafts someone made the form and another provided the finish. Therefore, many of the objects in this exhibition are the products of communal workshops as well as individuals working alone.

Objects have been selected to reflect, also, a diversity of materials, tools, and techniques of manufacture as well as a breadth of utility. For example, in the broad area of fiber and weaving there are multiple examples of textiles, baskets and related woven pieces; and of baskets alone there are various kinds, such as work baskets, fancy baskets, and those made of wood, splint, bamboo and grasses.

For many years I have had a particular fascination for older traditions that continue to exercise influence on succeeding generations of artists and people of craft. Because both the Shakers and the Japanese are renowned for their distinctive designs and aesthetic standards, I wanted to understand to what degree, if any, the traditional crafts of these two cultures had been brought into the mainstreams of contemporary art.

For this reason there are a few selections that represent a broad range of contemporary work in America and Japan. Included are pieces by American artists known for careful reproductions and free interpretations of Shaker designs, and of Japanese artists working in traditional forms for contemporary use.

One piece in particular represents an important cross-over between American and Japanese styles–the table by George Nakashima (1905-1990), born in Spokane, Washington, of Japanese parents, who once described his style as "Japanese Shaker."[4]

Chronologically, the most recent piece in the exhibition is the lacquer and paper-covered bamboo clothing chest *(hari kago)*, completed in February, 1995, by Tatsuo Matsuda, the fourteenth generation head of his family. However, it is not a "modern form"; for he continues a tradition in the same location where his ancestors have made these baskets for over four hundred years. Now in his 90s, Tatsuo Matsuda is the last of the makers of the famous Kyoto *hari kago.*

Combined, these objects represent almost two hundred years of history, but a few reflect traditions that extend backward into the mists of unrecorded time. Two of the most ancient crafts in the exhibition are textiles and paper. A bolt of loosely woven, coarse hemp cloth *(asa nuno)* commonly used in rural Japan until recent years, is typical of a variety of regional textiles woven for hundreds of years from bast fibers of plants such as nettle, elm, kudzu, mulberry, wisteria and banana. *Asa* cloth is kin to *angin*, a knitted bast textile that can be dated as far back as the Joomon Period, the last phase of which ended around 250 BC.

Distinct differences in the histories of the American Shaker and Japanese cultures make comparisons difficult. Even at their height the Shakers have remained but one utopian society within the great diversity of American culture. Today they have declined to one small community at Sabbathday Lake, Maine, whose mission is to sustain the United Society of Believers as a part of the spiritual life of America. They are not a living museum of the Shaker past. They no longer need nor have time to spin and weave textiles for clothing and domestic use, weave baskets, or make oval boxes or chairs.

Only insofar as such hand work serves their mission do they continue any of these traditions today.

The Japanese, in comparison, are an entire people, an island nation that for several thousand years has been defined by geographical boundaries and a culture distinct from its neighbors in Asia. And while craft traditions disappear each year in great numbers, thousands of potters, basket makers, lacquerers, spinners, dyers, weavers and furniture makers–to name only a few, continue to produce traditional and modern objects for use in Japanese homes and throughout the world.

Among the many differences between the Shakers and the Japanese, the greatest contrast would appear to be the outward expressions of religious ideologies. Yet, their spiritual orientations may be the point at which they are closest; they both share a deep reverence for the unseen sources of their inspirations.

The invisible realm of the anima, as Yoshida describes the mysticism of Japan, is a diverse pantheon of *kami*, the Gods of Shinto, the oldest and most unifying influence throughout Japanese history. They are omnipotent and omniscient– in water, wind, stones and trees. One need only to clap hands to draw their attention. When a woodsman or a carpenter cuts a tree or a piece of wood, he does so with great care, and with utter reverence for the *kami* that resides there. And what an artist or an artisan makes of a piece of wood must pay supreme reverence to the unseen spirit whose home it remains. This is George Nakashima's "soul of a tree."

The most powerful influences among the Shakers at the time when their spiritual revival flourished were the frequent blessings, or "Gifts," received by Brothers and Sisters throughout the United Society, thereby producing irrefutable physical evidence of God's

loving presence. These gifts appeared in the form of "spirit" drawings, poems and songs, or even designs for chairs. Such gifts from the holy spirit were received by members of the community without predictability–in a dream, a vision, or in a moment of spiritual ecstasy. Like leaven, these gifts enriched the lives of their spiritual families and Shaker communities far and wide, because they were shared from the common and endless well of divine blessing. As Thomas Merton once wrote, "The peculiar grace of a Shaker chair is due to the fact that it was made by someone capable of believing that an angel might come and sit on it. Indeed the Shakers believed their furniture was designed by angels. . . ." [5]

Words too often pay more homage than objects require. In language describing things made by the Shakers and the Japanese, a word frequently used is harmony–harmony of all parts of an individual piece, and harmony with its environment. It is an appropriate word. However, the language of objects–form, shape, color, texture, purpose, also includes essence, that intrinsic, unchanging nature of a thing which, like light, can surround and resonate within us. These are the things that George Steiner calls "real presences." [6]

Footnotes

1. Merton, Thomas. Introduction, *Religion in Wood, A Book of Shaker Furniture*. E.D. Andrews, F. Andrews, p. IX. Indiana University Press, Bloomington and London, 1966.

2. Yoshida Mitsukuni. "Culture or Civilization," *Tsu Ku Ru: Aesthetics at Work*, ed. Yoshida Mitsukuni, Ikko Tanaka and Tsune Sesoko, p. 11. Cosmo Public Relations Corporation, Tokyo, 1990.

3. Steiner, George. *Real Presences*, p.17. The University of Chicago Press and Faber and Faber, Ltd., London, 1989.

4. Nakashima-Yarnall, Mira. Letter to author dated February 2, 1995.

5. Merton, Thomas. *op. cit.*, p. XIII.

6. Steiner, George. *op. cit.*, title page.

Chronology of Japan (C. 50,000 B.C. - Present)

C. 50,000 B.C.	Paleolithic Period	Until C. 11,000 B.C.
11,000 B.C.	Joomon Period	C. 11,000 - 250 B.C.
250 B.C.	Yayoi	C. 250 B.C.- 250 A.D.
250 A.D.	Kofun (Old Tombs) Period	C. 250 - 552 A.D.
552	Asuka Period	552 - 645
645	Nara Period	645 - 794
794	Hian Period	794 - 1185
1185	Kamakura Period	1185 - 1333
1333	Nambokuchoo Period	1333 - 1392
1392	Muromachi Period	1392 - 1573
1615	Edo Period	1615 - 1868
1868	Modern Period	
1869	Meiji	
1912	Taishoo	
1926	Shoowa	
1989	Heisei	to present

Additional Related Reading

Andrews, Edward Deming and Faith. *Fruits of the Shaker Tree of Life; Memoirs of Fifty Years of Collecting and Research.* Stockbridge, MA: The Berkshire Traveller Press, 1975.

Arts, P.L.W. Tetsubin, *A Japanese Waterkettle.* Groningen: Geldermalsen Publications, 1988.

Beale, Galen, Jim Johnson and Gerrie Kennedy. *Shaker Baskets and Poplarware: A Field Guide, Vol.III.* Stockbridge, MA: Berkshire House, 1992.

Burks, Jean M. and Timothy D. Rieman, *The Complete Book of Shaker Furniture.* New York: Harry N. Abrams, Inc., 1993.

Cort, Louise Allison and Kenji Nakamura. *A Basketmaker in Rural Japan.* Exhibition catalogue. Washington, DC, and New York, Tokyo: Arthur M. Sackler Gallery, Smithsonian Institution, in association with John Weatherhill, 1994.

Gordon, Beverly. *Shaker Textile Arts.* Hanover, NH and London: University Press of New England with Merrimack Valley Textile Museum and Shaker Community, Inc., 1980.

Iwamiya, Takeji, Mitsukuni Yoshida and Richard L. Gage. *Forms, Textures, Images, Traditional Japanese Craftsmanship in Everyday Life.* New York, Tokyo: Weatherhill, (with Tankosha, Kyoto), 1982.

Kawakita, Michiaki, et.al. Tr. Erika Kaneko. *Craft Treasures of Okinawa.* Exhibition catalogue. The National Museum of Modern Art, Kyoto. Tokyo, New York, and San Francisco: Kodansha International, 1978.

Morse, Edward Sylvester. *Japan Day by Day: 1877-79, 1882-85.* Atlanta, GA: Cherokee Publishing Company, 1990.

Nakashima, George. *The Soul of a Tree, a Woodworker's Reflections.* Tokyo, New York, London: Kodansha International, 1988.

Okada, Takahiko. *Isamu Noguchi: Space of Akari and Stone.* Exhibition catalogue. The Seibu Museum of Art, Tokyo. San Francisco, CA: Chronicle Books, 1985.

Patterson, Daniel W. *Gift Drawing and Gift Song.* Sabbathday Lake, Poland Spring, ME: The United Society of Shakers, 1983.

Pearson, Richard, et.al. *Ancient Japan.* Exhibition catalogue. Arthur M. Sackler Gallery, Smithsonian Institution. Washington, DC and New York: George Braziller, 1992.

Rocheleau, Paul and June Sprigg. Ed. David Larkin. *Shaker Built: The Form and Function of Shaker Architecture.* New York: A David Larkin Book/The Monacelli Press/Penguin, 1994.

Sneider, Lea. *Kanban: Shop Signs of Japan.* Exhibition catalogue. Japan Society and The American Federation of Arts in association with the Peabody Museum of Salem. New York and Tokyo: Weatherhill, (n.d.).

Sprigg, June and Jim Johnson. *Shaker Woodenware: A Field Guide, Vol. I.* Great Barrington, VT: Berkshire House, 1991.

Stein, Stephen J. *The Shaker Experience in America: A History of the United Society of Believers.* New Haven and London: Yale University Press, 1992.

Urushi Study Group, N.S. Brommelle and Perry Smith, eds. *Urushi.* Tokyo: The Getty Conservation Group, 1985.

Wetherbee, Martha and Nathan Taylor. *Shaker Baskets.* Sanbornton, NH: Martha Wetherbee Basket Shop, 1988.

Yanagi, Soetsu. *The Unknown Craftsman: A Japanese Insight Into Beauty.* New York, Tokyo: Kodansha International, 1978.

Special Thanks

This exhibition could not have been realized without the generous support of a great many institutions and individuals in the United States and Japan.

We gratefully acknowledge all who have served as advisors in various capacities and provided significant assistance: In New England – Leslie Bedford, former Director of the Japan Program at Boston's Children's Museum and now Assistant Director for programs at the Brooklyn Historical Society; author, June Sprigg Tooley; Gerrie Kennedy, Richard Dabrowski, Martha Wetherbee, Nathan Taylor, and Timothy Rieman. In Tokyo – Sori Yanagi and Tsune Sesoko of the Japan Folk Crafts Museum; Hiromu Okada of Bingoya; Naokuni Shiga of Takumi Ltd.; Amaury Saint-Gilles; the curatorial staff of the Craft Gallery of the National Museum of Modern Art. In Osaka – Tadao Umesao, Komei Sasaki, Fumio Uno of the National Museum of Ethnology. In Kyoto – the curatorial staff of the Kyoto Museum of Modern Art. In Mariko Village, Shizuoka – Hiroshi Kawaguchi. In Mashiko Village – Tatsuzo Shimaoka. In Kurashiki – Kichinosuke Tonemura of the Kurashiki Museum of Folk Crafts. In Aomori City and environs -- Chuzaburo Tanaka and Midori Okada of the Keiko Kan, and Chicko Terayama and Minao Ida of the Kobo Michinokuori; Yoshio Mochizuki of the Aomori Prefectural Kogyo Shikenjyo, Lacquer Research Program and Kyoji Mikami. In Okinawa – Toshiko Taira and Mieko Taira, Kijoka; Jissei Omine, Yomitan Village; Setsuko Yamazato, Ishigaki City. In Hokkaidoo – Shigeru Kayano of The Ainu Culture Museum, Nibutani and Takuo Nambo of the The Ainu Musuem, Sapporo. Others who contributed substantially were Mikio Higa, Miyoko Higa and The Fullbright Association of Okinawa; Atsuko Shiraishi of The Kyoto International Cultural Association; Susetsu Kawakami; Hiroshi Kawaguchi; Kuniyoshi Munakata, Takako Iwasaki of The Aomori Foundation for Advancing International Relations; Mariko Fukuda; Yasuko Kunita; Miho Munakata; Yasuko Takahara, Masamitsu Takahara, Satoko Takahara, Teruo Takahara and Tetsuya Nakamura.

Loans from Japan have been facilitated by several people: Kenji Shimonaka and Hiroshi Mitsuke of the Kitamaesen Museum and Kaga Board of Education; Shin-ichiro Yoshida and Kazuo Moriya of Audry, The Design, Inc.; Yasko Araki, Kyoto City International Foundation; Dai Williams; Mizuho Iwata; Diane Durston; Kiyoshi Ota; Ikuyo Morrison; and Hisae Hasegawa.

Translation of Japanese language materials has been provided by Kiyoko Morita, Yasuko Bush, Keiko Thayer and Makoto Yabe.

This project was inspired by the original commitment of The Council for the International Exchange of Scholars, The Japan-United States Educational Commission, The Fulbright Program and The Fulbright Foundation in Tokyo, for the award of a Senior Research Fellowship in Japan in 1991. Particular appreciation is expressed to Caroline A. Matano Yang, then Director of the Tokyo program and Mizuho Iwata, Program Specialist; and to Doshisha University, Kyoto, and Professor Otis Carey, Tadahiko Chogo and Yoshimi Matsuura, of the International Liaison Office for the appointment as Visiting Scholar.

William Thrasher

MEETINGHOUSE SIGN AND SIGNPOST

Pine, chestnut, black and white paint
Sign, 73 x 73 x 10 cm; height with post 287cm
Attributed to Amos Stewart and Giles Avery,
Church Family, New Lebanon, New York, 1842
Hancock Shaker Village, Pittsfield, Massachusetts 62-211a, Ex Miller Collection

From their earliest years in America the Shakers opened Sunday worship services to visitors in the interest of spreading their message and of attracting converts. From the point of view of the outside world, the Shakers' dance worship was an attraction unlike any other religious service.

An intensely spiritual revival movement known as "Mother Ann's work" began in 1837, however, and led to a change in the service. Inspired members received from the holy spirit gifts of song, whirling or leaping, and speaking in tongues. The services became so extraordinary that early in 1842 the Parent Ministry at New Lebanon declared an end to public services. The ministry ordered signposts erected in front of the meetinghouse and the office with cross-shaped signs that slid into place on Sundays to inform visitors of the change. In 1845, when the spiritual manifestations had subsided in intensity, the Ministry reopened the services; and the signs were removed.

SHAKER FURNITURE

"People look in upon us and that's the first thing they say. "Oh, they're the people that made that nice furniture, they made nice chairs and tables." And I say, "I know it, I almost expect to be remembered as a chair or a table."(*)

In the beginning Shaker communities made, bought or traded according to their needs. With the growth of their communities in number and size, production of furniture for their needs became a part of Shaker life. Shaker furniture--chairs in particular, has become almost an icon of the American Shakers in the eyes of the world.

(*) Eldress Mildred Barker, interview, Gerard C. Wertkin, *The Four Seasons of Shaker Life*, page 134.

ROCKING CHAIR WITH ARMS

Ribbon maple, maple, birch, stain, varnish, replacement cane
114.2 x 58.7 x 66.4cm
New Lebanon, New York, 1850-1860
Hancock Shaker Village, Pittsfield, Massachusetts 75-195.2

The use of naturally patterned wood was discouraged by the most conservative Shakers as unnecessarily vain and showy. Others, however, accepted the use of dramatic woods such as flame birch or cherry, and bird's-eye, curly or ribbon maple, as in this large chair.

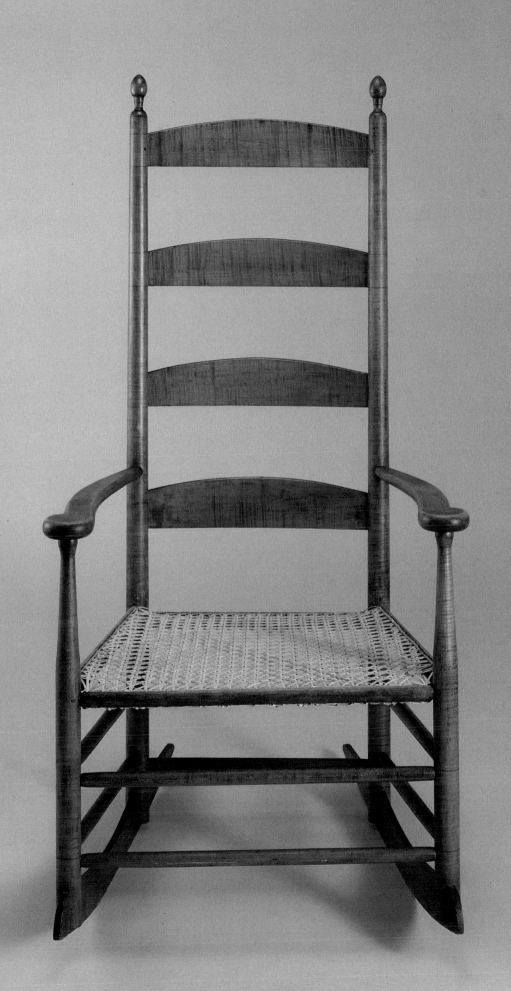

CASE OF DRAWERS

Curly maple and pine, light varnish
144.8 x 104.4 x 55.3cm
Union Village, Ohio, c.1840
The Art Complex Museum, Duxbury, Massachusetts 91.23

Distinctive designs, craftsmanship, and use of indigenous woods have
come to be expected in furniture of the western states of Ohio and
Kentucky, and particularly in that of Shaker cabinet-makers. This extraordi-
nary case of drawers, however, is in a class of its own. It belongs to that
notable group of Shaker pieces considered masterpieces of American fur-
niture-making.

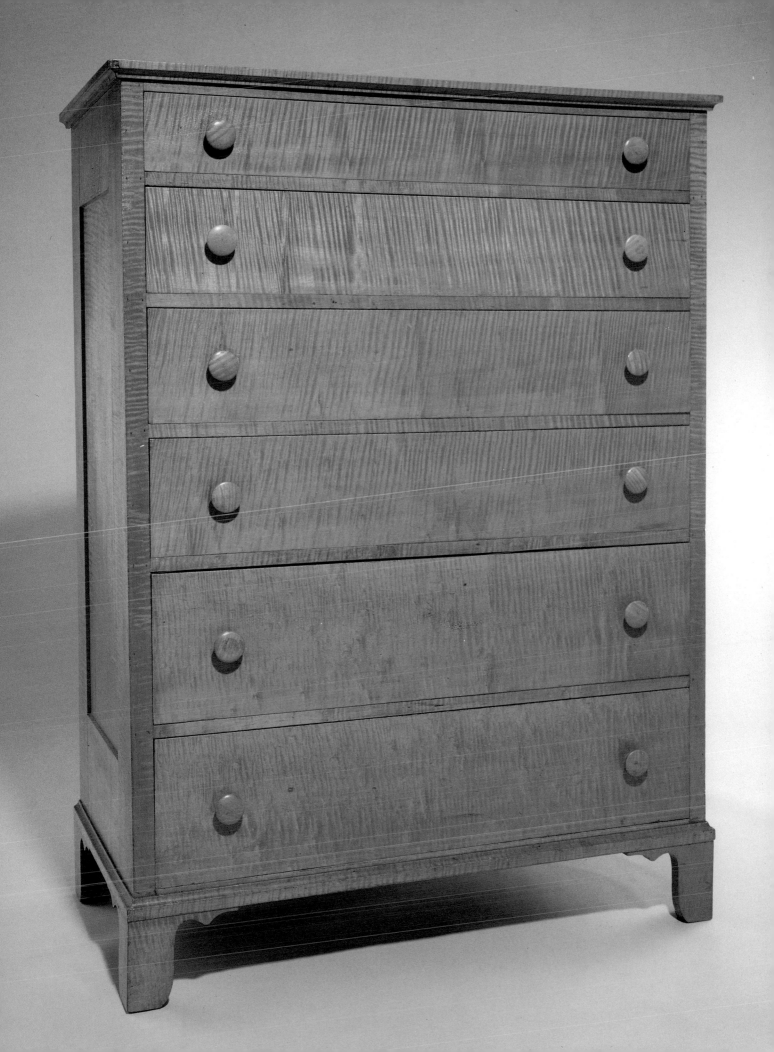

SEWING DESK WITH TWELVE DRAWERS

Pine, birch, walnut drawer facings and pulls, red and walnut stains,
ceramic lockplates, porcelain pull on extension
101.7 (rear height) x 78.7 x 60.9cm
Attributed to Elder Henry Green, Alfred, Maine, c.1877
The Art Complex Museum, Duxbury, Massachusetts 81.46

Workstands, later called sewing desks, were very popular among Shaker
Sisters from the 1860s to about 1890. Many examples were marked with
the name of the maker and of the sister for whom it was made. This kind of
gift from a Brother to a Sister was considered permissible in the late nine-
teenth century as a token of Brotherly affection.

Many workstands had drawers on the front and on the side to make access
easier. This type of workstand was characteristic of the communities in
Maine and New Hampshire.

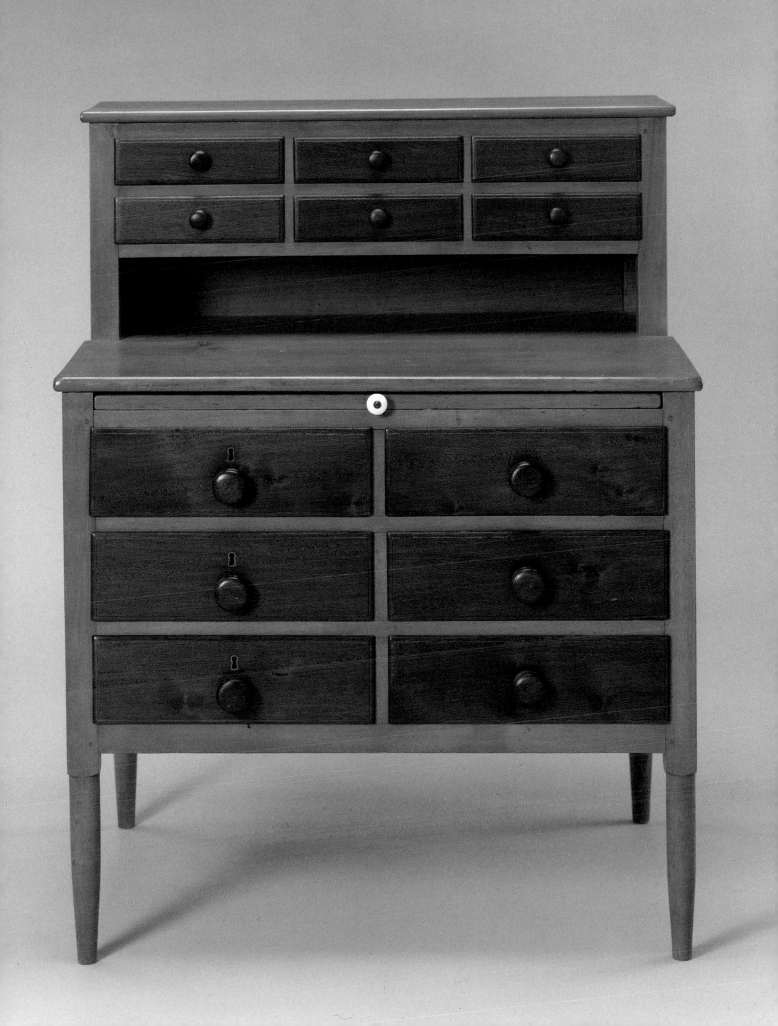

REVOLVING CHAIR

Pine seat, hickory back bar, oak shaft, maple base, wire, stain, varnish
69.2 x 43.2 x 39.4cm
Attributed to Mount Lebanon, New York, c.1850-1860s
The Art Complex Museum, Duxbury, Massachusetts 29.18

The long history of Shaker chair-making included several experiments in form and style. Revolving or "turning" chairs were introduced as a new line of chairs for sale by the South Family at New Lebanon, New York in the 1860s. Available in different sizes and styles, such as high stools, they proved convenient. Not only did they allow freedom of movement from left to right; but they also could be raised and lowered to different heights.

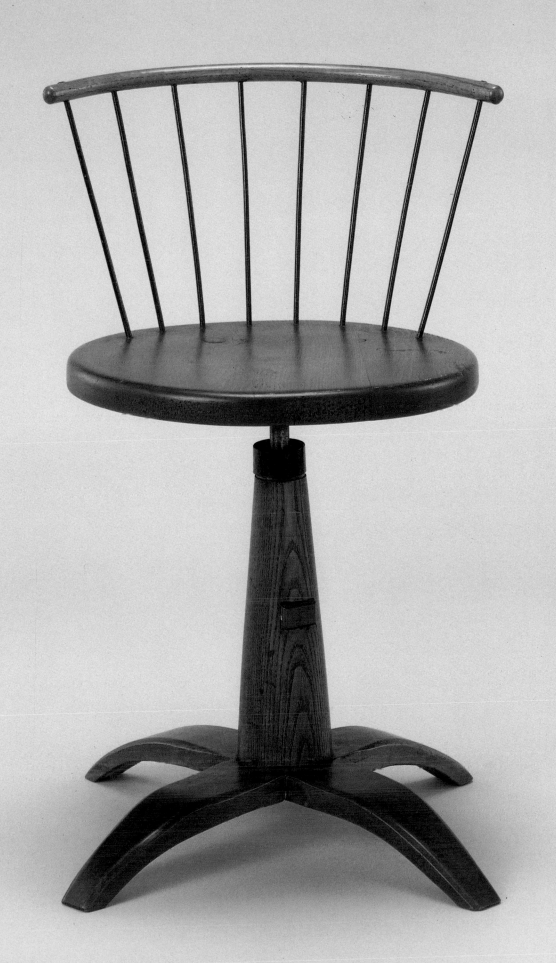

DWARF TALL CLOCK

Cherry case, pine back, glass, brass works and pendulum, steel weights,
iron hands and dial (painted off-white on front and dark red on back)
137 x 25.4 x 17.7cm
Painted in black on back of face, *WATERVLIET MADE BY BENJAMIN*
YOUNGS SENR IN THE 78TH YEAR OF HIS AGE. 1814
Stamped on brass works, *1814*
Written in ink on paper label below pendulum inside case, *WATERVLIET*
BENJAMIN YOUNGS SENR IN THE 78 YEAR OF HIS AGE 1814.
Watervliet, NY is opposite Troy. Benjamin Youngs was a Shaker in the
colony there.
The Art Complex Museum, Duxbury, Massachusetts 30.29

Shaker communities were summoned from sleep, to meals and to meetings
by bells. Because they were costly, neither watches nor clocks were com-
mon among the early Shakers. This dwarf clock, which is an alarm clock
when the central dial is set at a particular hour, combines the skill of a
trained and skillful clock-maker, Benjamin Youngs, Sr., and an unidentified
cabinet maker. Of the twelve clocks by Youngs extant, most are full-size
versions of this dwarf clock.

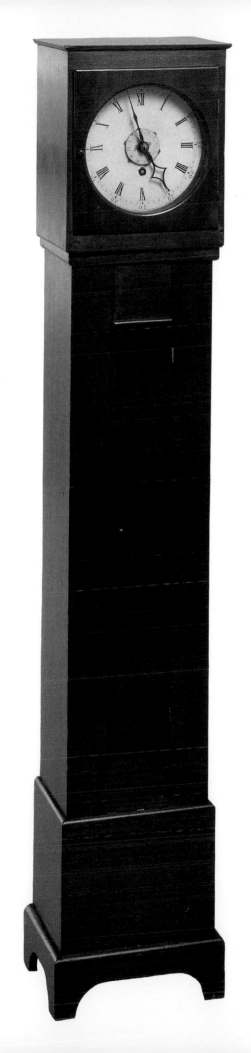

BED

White pine headboard and posts, hickory pins, maple wheels,
green paint, rope
86.4 (including headboard) x 80 x 188cm
c.1820-1830
Hancock Shaker Village, Pittsfield, Massachusetts L86-2.2, Lockwood Collection

The surprising color of this well-known bed astonishes many who see it for the first time. How "un-Shaker" it seems! It is far more surprising to learn that this bed fulfills to the letter the Millenial Laws that served as guidelines for the daily lives of the Shakers. The first order in Section X, of the 1845 revision of the Laws, which is titled "Orders concerning Furniture in Retiring Rooms," states:

> "Bedsteads should be painted green—Comfortables should be of a modest color, not checked, striped or flowered. Blankets or Comfortables for out side spreads, should be blue and white, but not checked or striped; other kinds now in use may be worn out."

Until about 1860, Shakers of the same sex slept in pairs in double beds. After that, single beds became standard. Some beds, such as this example, were cut down from double to single size. The reason for the stipulation of green paint is not known, although perhaps a chemical ingredient in green pigment was poisonous to bedbugs, a universal housekeeping problem in the nineteenth century.

Shaker beds were similar to American beds of the time, but the wheels were distinctive Shaker additions, making daily cleaning under the beds more convenient.

LAP DESK

Stained butternut
12.7 (rear) x 50.2 x 40.6cm
Hancock Shaker Village, Pittsfield, Massahusetts 63-22

Desks of all kinds, including the convenient small, portable writing boxes known as lap desks, were made for use in each Shaker community. Writing was an activity ordinarily reserved for scribes appointed to keep the family journal of daily events, and for leaders. Many heads of work departments, including farmers, gardeners, physicians, tailors, basket makers, and the like, were given the task of recording their output and progress. All together, Shakers wrote and preserved thousands of journals that provide an excellent record of Shaker history and daily life.

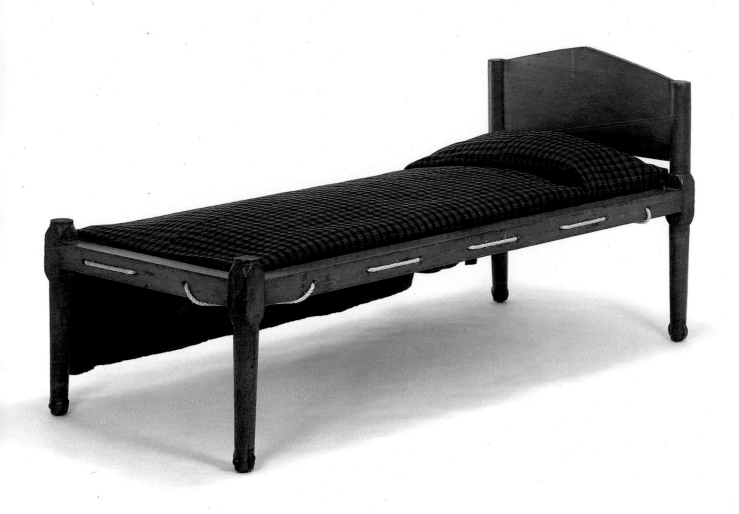

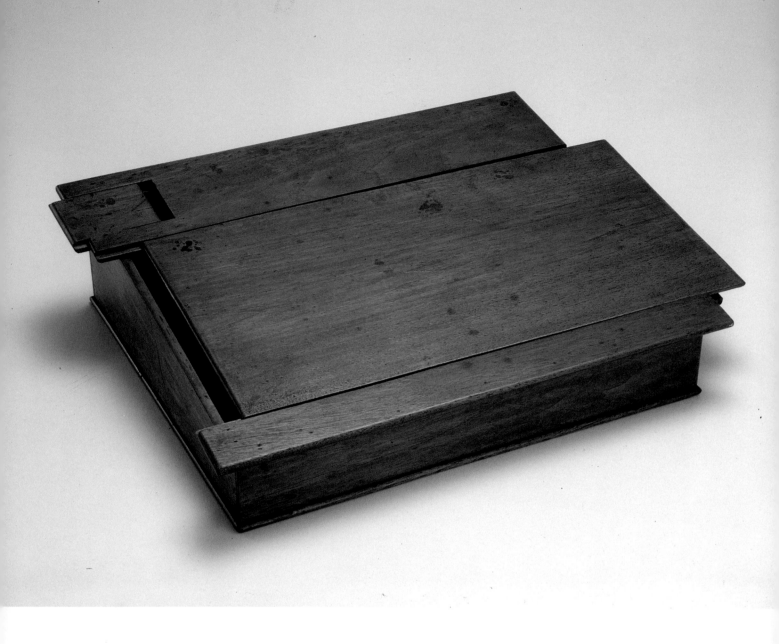

HANGING BRACKET FOR CANDLE OPPOSITE

Pine, cherry, brown stain, nails
49.5 x 12.2cm
Miid-19th century
Hancock Shaker Village, Pittsfield, Massachusetts 64.209, Ex Sheeler Collection

Brackets for candles and mirrors were among many household furnishings designed to be hung from the peg boards found throughout Shaker dwelling houses.

42

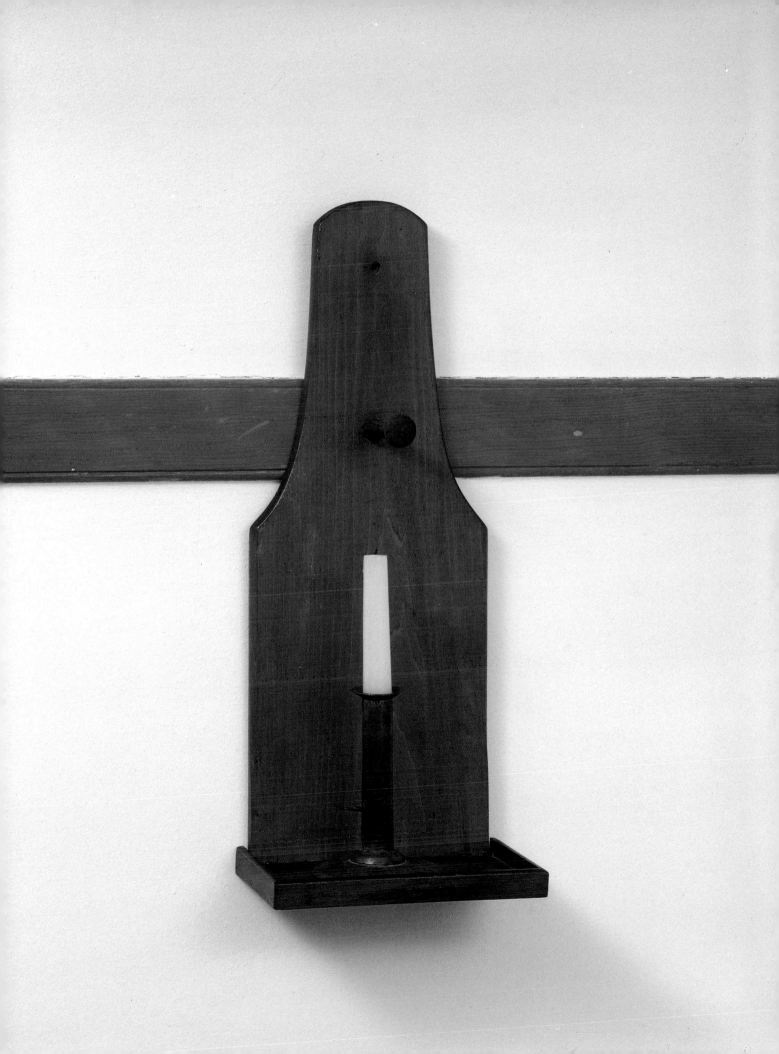

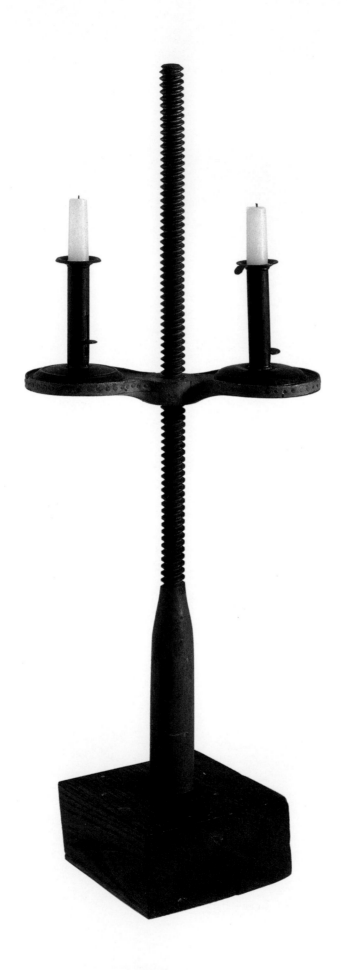

44

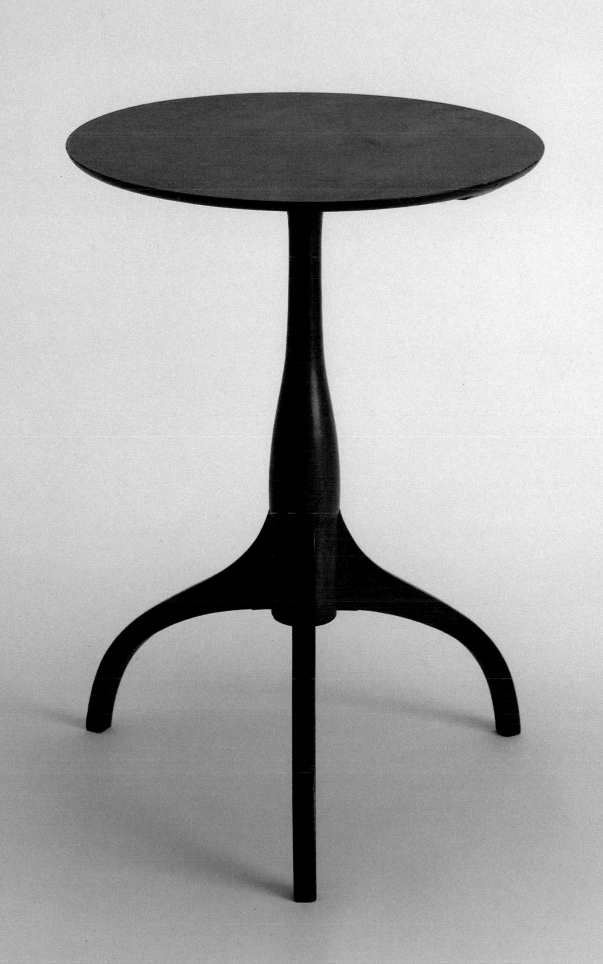

ADJUSTABLE DOUBLE LAMP STAND

PAGE44

Oak, chestnut, birch, red stain, leather, iron
84.1 x 30.5 x 17.8cm
New Lebanon, New York, c.1830-1850
Illustrated with candlesticks known as "hogscrapers" because the round bases were used to scrape hair from hog's skin.
Machine-made tinned sheet-iron, painted black
With height adjustor: 12.5cm; without adjustor 12.3cm
Hancock Shaker Village, Pittsfield, Massachusetts 62-575, Ex Andrews Collection 62-691, 62-78

A shoemaker or tailor probably used this lampstand, raising or lowering the lights as needed to see his work clearly. It is shown with candlesticks but could also be used with glass or tin lamps filled with whale oil. The faded orange color on the wood is a red lead stain, which was favored by the Shakers on woodenware.

TRIPOD STAND

PAGE 45

Cherry, iron
64.1 x 43.1 x 44.8cm top diam.
New Lebanon, New York, 1820-1830
Hancock Shaker Village, Pittsfield, Massachusetts 62-8, Ex Andrews Collection

MUSIC STAFF PEN AND CASE

OPPOSITE

Pen, mahogany handle and brass; case, fruitwood, brass rivet, tin washer
Pen: 10.9 x 1.3cm diam.; case: 13.9 x 1.91 x 1.5cm diam.
Attributed to Isaac Newton Youngs, New Lebanon, New York, c.1840
Hancock Shaker Village, Pittsfield, Massachusetts 71-139 a,b

From the wordless tunes that characterize the first Shaker songs to the development of text sung in harmony, many Shakers spent considerable time writing songs and hymns as well as music for dances that were part of Shaker religious ritual. In the period between the 1830s and the 1880s they had developed a music theory and notation that was notably different from that of the outside.

Even when writing non-harmonized music on a single melodic line, the five-line staff became customary for the Shakers. Thus, five-pointed ink pens such as this served to expedite the preparation of music paper before notes were written in.

The partially completed music is from an untitled Shaker manuscript in the library at Hancock Shaker Village (9775.A1).

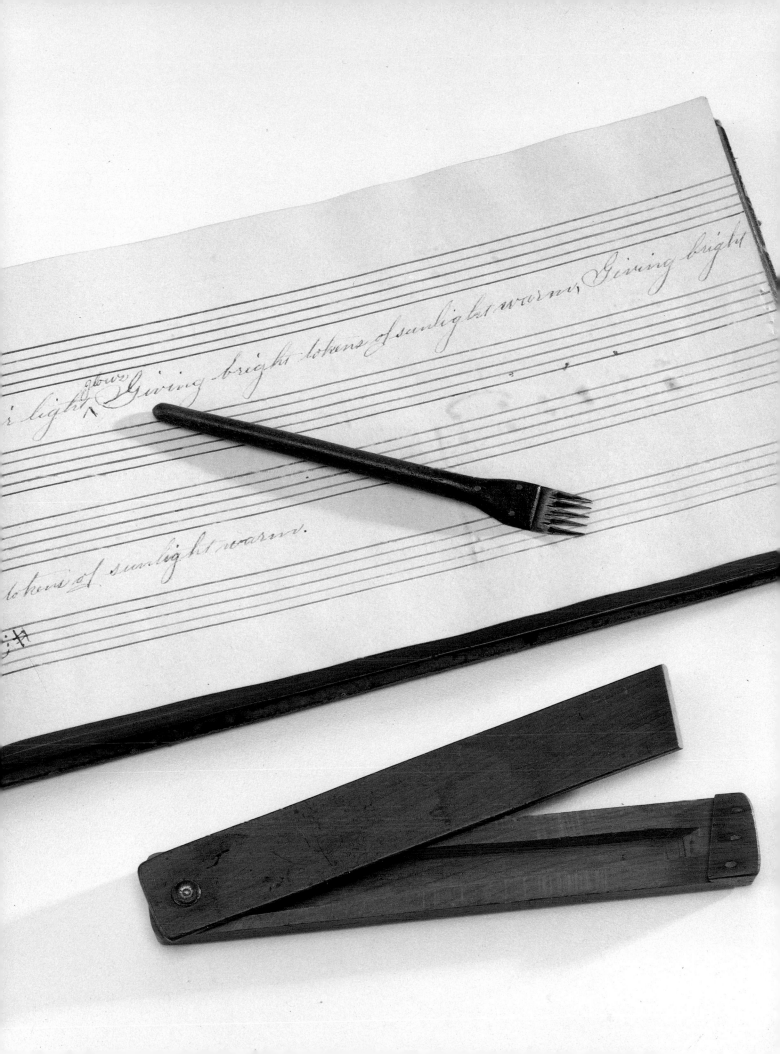

SHAKER TEXTILE TOOLS AND EQUIPMENT

Textile making, tailoring and sewing was a major part of the daily life of Shaker Sisters and girls primarily, but the manufacture of tools and equipment for textile work brought many Shaker brothers into near collaboration with the Sisters. Not only was there continual demand for clothing within the Shaker communal families, but also for a wide variety of other household textiles--woven rugs, bed coverlets, curtains, chair tape, towels, laundry bags, etc. Particular garments, such as the "Dorothy" cloaks, were also in great demand from the outside world.

YARN REEL

Maple, cherry post and legs, birch and maple frame,
red stain, iron plate and pointer, paper label
108.6 x 65.4 x 40cm
P carved under dial
Attibuted to Enfield, Connecticut, 1820-1830
Hancock Shaker Village, Pittsfield, Massachusetts 62-526.4

Clock reels were an aid in the winding of volumes of spun yarn into accurately measured skeins. As the reel was turned, a pointer and dial counted the revolutions and made a click when the correct number had been reached. The Shakers did not invent this useful tool, but this example is remarkable for the exceptional care that was given to its design and workmanship.

LAUNDRY CARRIER PAGE 50

Hardwood
38.4 x 106.1 (including handles) x 45.1cm
Hancock Shaker Village, Pittsfield, Massachusetts 62-384 a, Ex Parsons Collection

Carriers such as this were common in Shaker communal laundries. Carriers would be filled with wet clothing, probably allowed to drain, and then carried by two Sisters to an attic where the rising heat in the building created an ideal environment for drying.

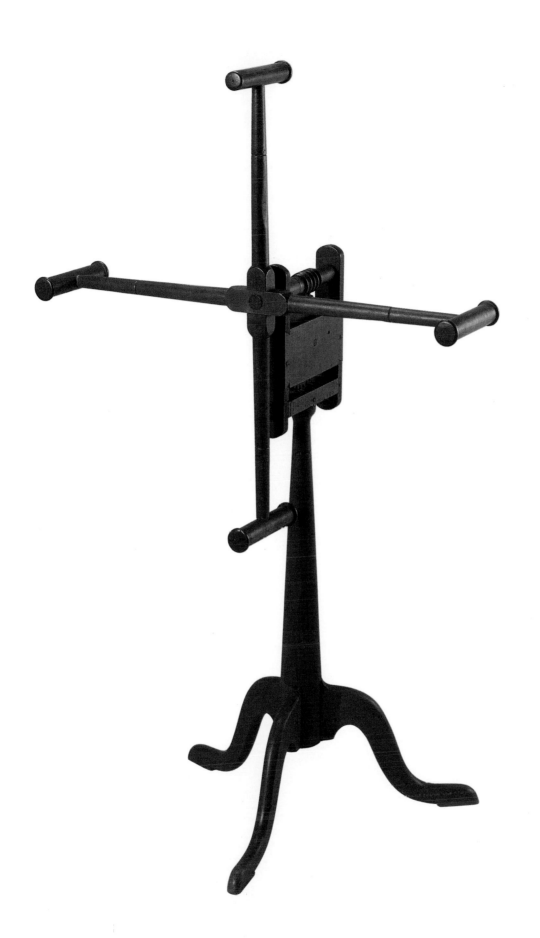

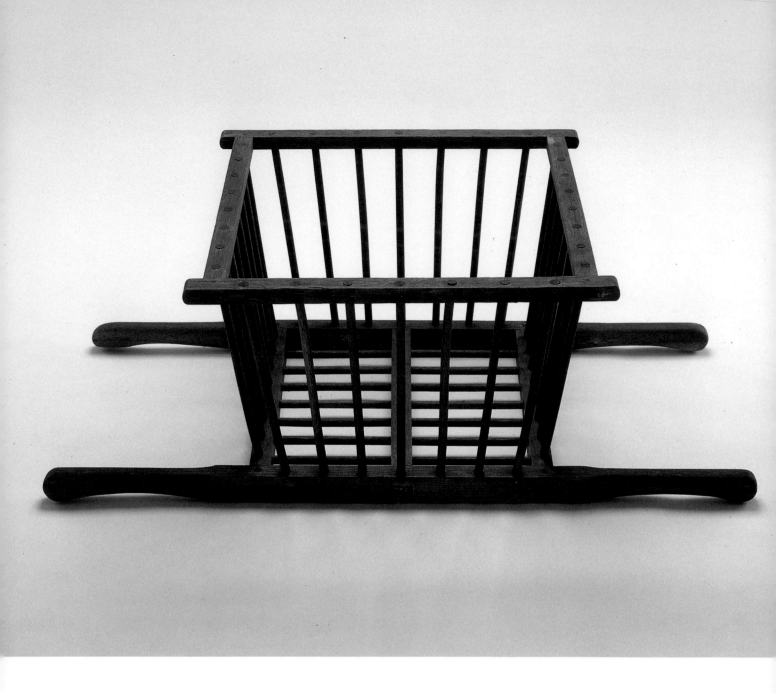

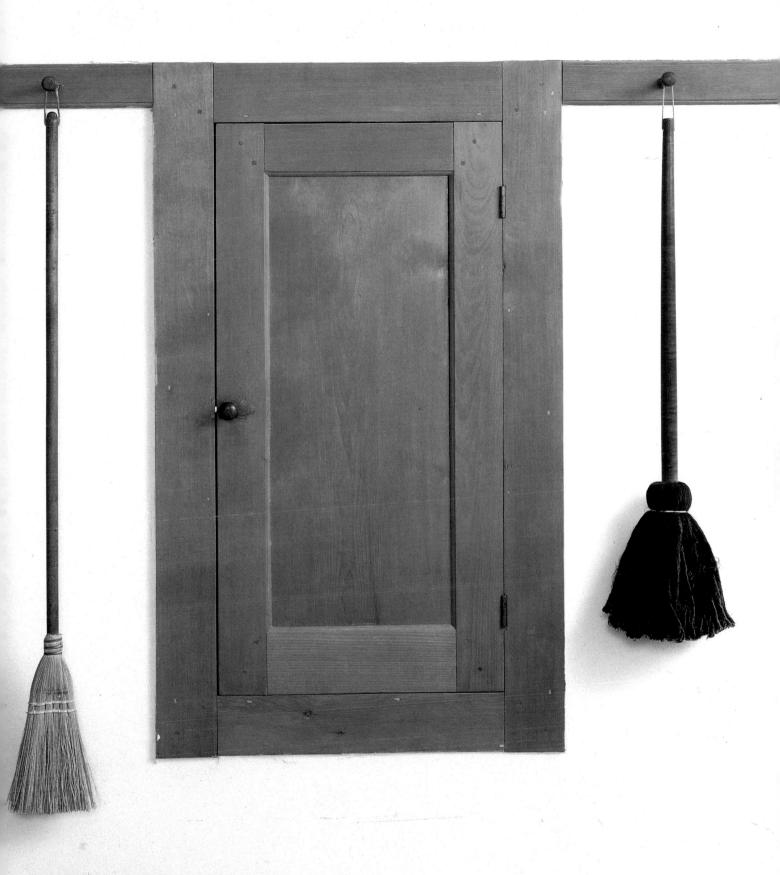

SMALL BROOM

PAGE 51

Wood, brown stain, broomcorn straw, cotton string, wire
97.8 cm
Hancock Shaker Village, Pittsfield, Massachusetts 71.328.x a

Broom-making represented a substantial industry in many Shaker communities. Throughout America, early brooms were typically round. It is Shaker documents that record the creation of the flat broom around 1800, which is attributed to the hands of Brother Theodore Bates (1762-1846), who supervised a broom-making operation for many years at Watervliet, New York. The invention of the flat broom is characteristic of Shaker ingenuity in making the ordinary tasks of daily life easier.

DUST MOP

PAGE 51

Curly maple handle, red-brown stain, indigo dyed wool mop head
83.8 (overall length) x 1.9cm (handle diam.)
Hancock Shaker Village, Pittsfield, Massachusetts 71-344

The unusual use of curly maple for a mop handle tells us that this is not an ordinary commercial piece, and probably was for Shaker use.

RABBET PLANE

PAGE 53

Yellow birch, iron, steel
19 x 40.6 x 6.7cm
Attributed to Canterbury, New Hampshire, early 19th century
Hancock Shaker Village, Pittsfield, Massachusetts 78-57.87

Listed as a "Jack rabbet plane" and "skew iron," this woodworking plane has been designed to groove or cleanly cut across the wood grain in preparation for joining two pieces of wood.

KITCHEN CHOPPING KNIFE

PAGE 54

Iron, steel, white oak, brass rivets
21.9 x 30.2 x 4.1cm
c.1840-1850
Hancock Shaker Village, Pittsfield, Massachusetts, 63-1210 a, Ex Andrews Collection

This chopping knife is about twice as large as most ordinary examples, allowing a Sister to prepare food more quickly for a communal family of up to a hundred people.

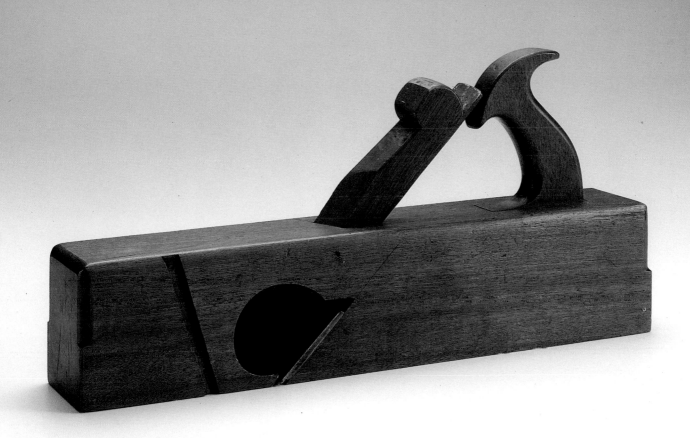

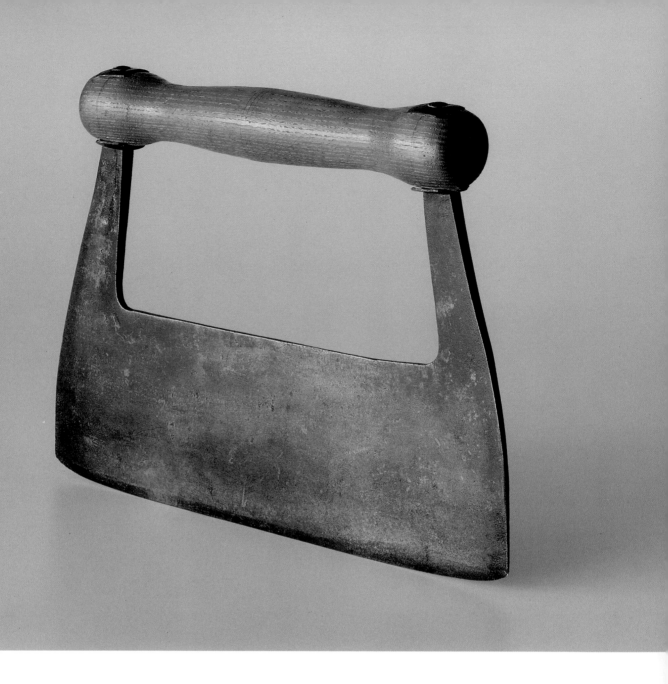

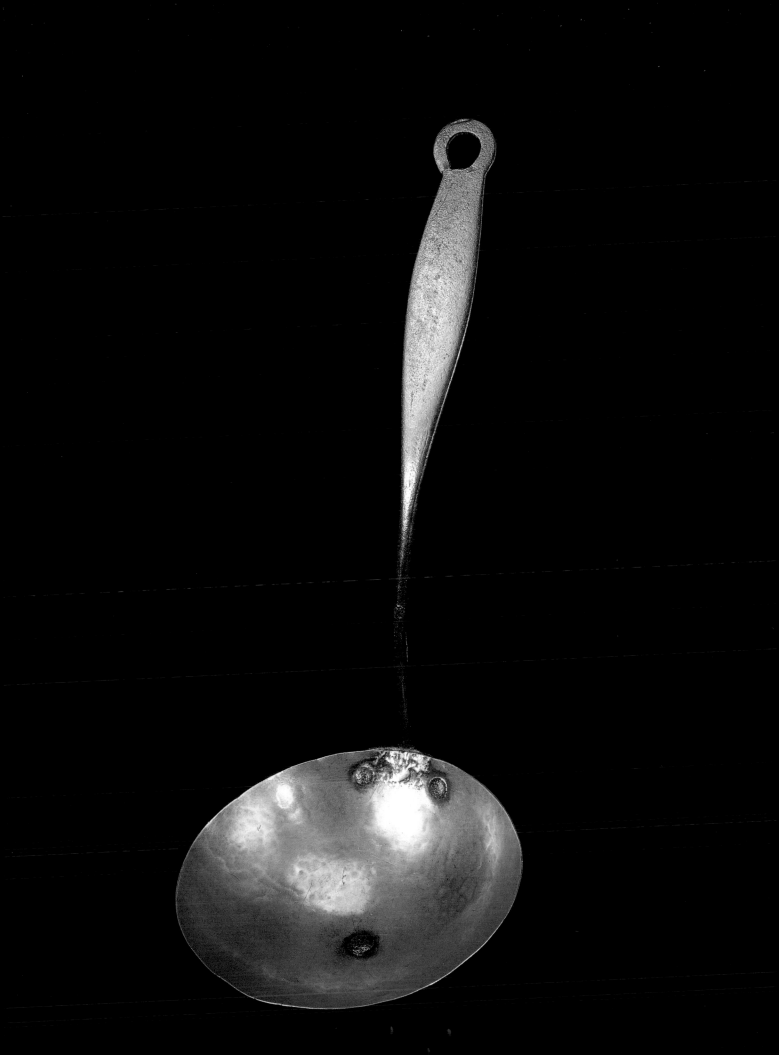

KITCHEN LADLE

Brass and iron
20 x 10.2cm
Attributed to Hancock, Massachusetts, 1800-1825
Hancock Shaker Village, Pittsfield, Massachusetts 62-846
Ex Coffee Collection

STOVE

Iron, paint, maple
44.4 x 89.3 x 41.5cm
Probably Hancock, Massachusetts, first half of 19th century
Hancock Shaker Village, Pittsfield, Massachusetts 74-83.7

This stove's design is the essence of practicality: small, low in height, and designed for efficiency. It has special features such as a place for heating irons and a rack suspended underneath for fire tools or stone bedwarmers.

The placement of stoves in Shaker workplaces and residences was carefully considered. When a stove was placed well into a large room, the unusual lengths of pipe that were required added a boldness to the generally quiet interiors.

TONGS AND SHOVEL

Iron
Tongs, 49.5 x 7 x 1.9cm; shovel: 58.4 x 12.1 x 3.8cm, c.1830-1850
c.1830-1850
Hancock Shaker Village, Pittsfield, Massachusetts 74-83.1.3 & 4

When looking closely at these two remarkable pieces, it is difficult to understand how such fine details could be produced by hammering, for that is the process by which they were made. The soft, glistening finish, revealing the beautiful silver color of the iron, was accomplished with files (the fine markings are visible) by a whitesmith, considered the most skilled of blacksmiths.

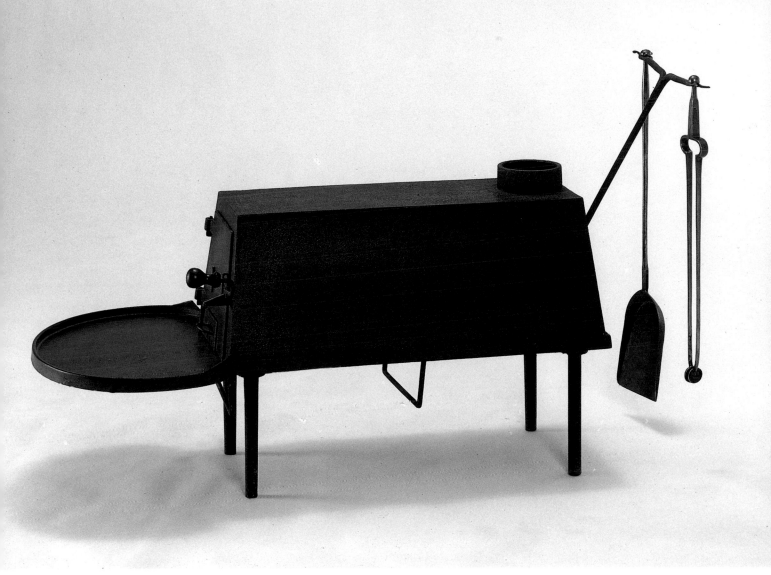

BENTWOOD DIPPER

Birch, white pine bottom, maple, iron, copper
16.5 x 26.7 x 11.8cm
Attributed to Giles Bushnell Avery, New Lebanon, New York, 1830-1845
Hancock Shaker Village, Pittsfield, Massachusetts 67-108, Ex LaBranche Collection

Like the well known oval boxes, these measures are made of thin strips of maple that were soaked or steamed until flexible, then bent on forms. The turned handles were attached with two rivets underneath.

Dippers or dry measures were used to measure grains and other dry goods. The New Lebanon Shakers produced them in several sizes for use at home and for sale. Giles Avery was in charge of the dipper-making operation for ten or more years. He eventually rose to serve in the highest position of authority, the Parent Ministry based at New Lebanon.

LARGE OVAL CARRIER PAGE 60

Birch bentwood sides and rim, hickory handle, white pine bottom, yellow stain on body, red stain inside bottom, iron nails, brass tacks and washers
25.4 x 60.9 x 45.7cm
Harvard or Shirley, Massachusetts Shaker communities, 19th century
Hancock Shaker Village, Pittsfield, Massachusetts 80-16, Ex Gould Collection

While the basic forms of oval Shaker carriers are the same, they appear in many variations: some lidded; some with fixed handles; some with moveable handles.

Many Shaker communities cultivated herbs and gathered wild medicinal plants for their own use and for sale to pharmaceutical companies. This large, lightweight carrier was used for gathering herbs. Bright yellow and dark red were colors commonly used by the Shakers for their oval boxes as well as for furniture and household woodenware.

SMALL OVAL CARRIER PAGE 61

Cherry sides and handle, varnish, pine bottom, copper tacks and washers, iron rivets
13.9 x 17.8 x 11.9cm
Trade mark stamp underneath:*Sabbathday Lake Shaker, Maine*
Sabbathday Lake, Maine, early to mid-19th century
Hancock Shaker Village, Pittsfield, Massachusetts 66-169

Oval boxes and carriers did not originate with the Shakers. However, the fingered fastenings called "swallow tails" have become an icon of designs unique to the Shakers. Named by the Shakers for their resemblance to the tail feathers of the familiar bird, these finely worked joints were resistant to warping.

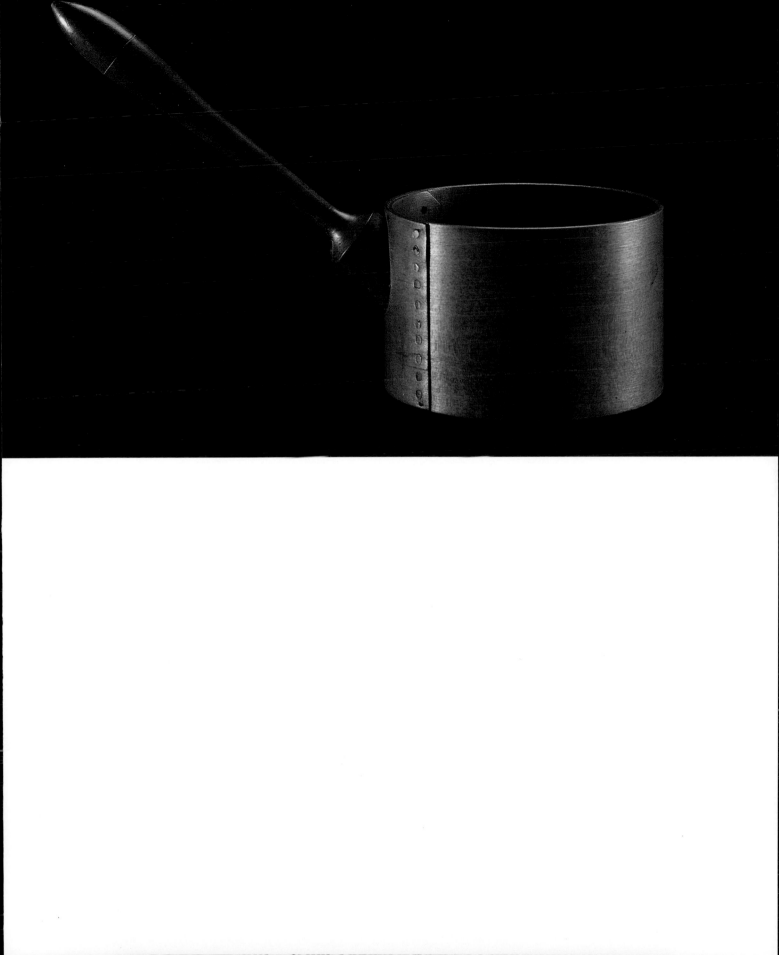

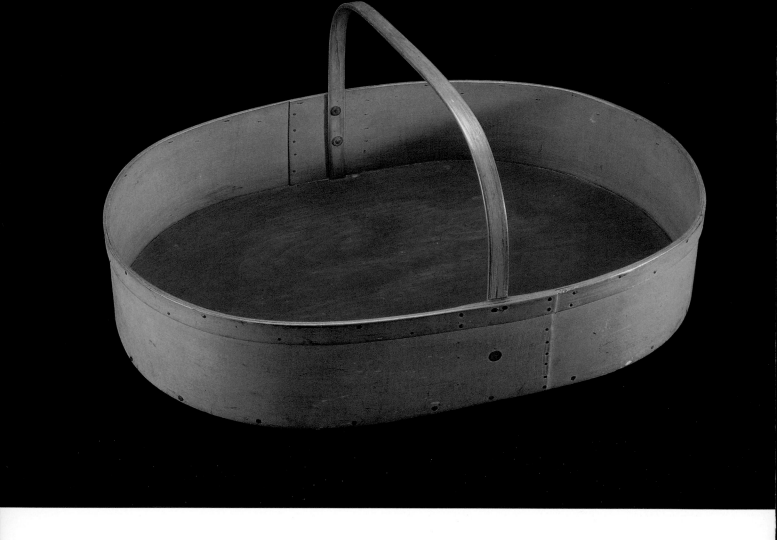

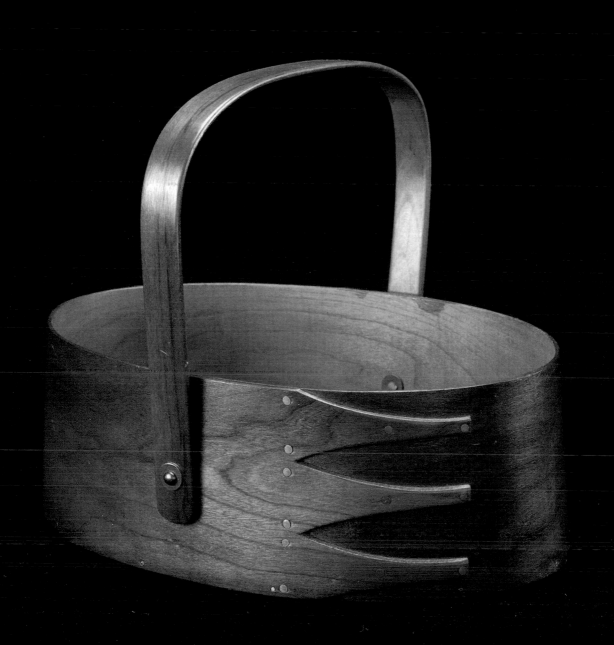

PAILS AND DIPPER

Wood, paint, varnish, copper, iron
New Lebanon, New York, 19th century
Hancock Shaker Village, Pittsfield, Massachusetts

The Shakers made pails for milking, berry picking, and for collecting the sap of maple sugar trees in late winter to make sugar and syrup.

STRIPED FANCY PAIL

Attributed to Brother Rufus Crossman or Daniel Boler, Mount Lebanon, New York
16.8 from rim x 24.1 bottom diam. & 25.4cm top diam.
In ink on back: illegible initials and ...*1884*
Ex Newton Collection 63-543

In 1875, the great communal dwelling of the Church Family at New Lebanon, built in 1787, was destroyed by fire along with other buildings. Some of the cedar fence posts survived. To commemorate that landmark event, one of the Brothers made about a dozen pails as gifts. He combined narrow strips of cedar with sumac, a weedy shrub ordinarily of little use, to make delicate pails that served more as mementoes than for any practical use.

DIPPER

22.9 (overall length) x 12.1 diam. x 6.4cm
Ex Andrews Collection 64-9

The gourd-like shape of this dipper, carved from one piece of wood, is one of only a few others known. All similar extant dippers share the same fine carving of the thin handle, which makes the dipper easy to use and serves as a hook for the rim of a pail.

BLUE PAIL

22.8 height to rim; 5.7 height of side ears x 30.5 bottom diam. and 31.1 top diam.
63-539

YELLOW PAIL

15.2 x 22.2 x 20.3 cm
in cross–stitch: *JB*
73-245.1.2

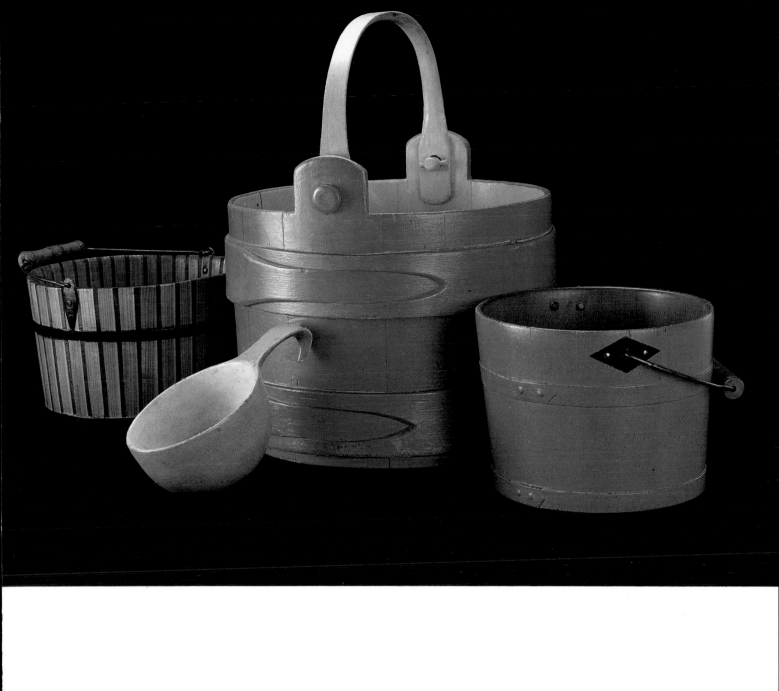

TUB

Wood staves and bottom, rust-red and white paint, iron hoops
53.9 height in back x 50.8cm top diam.
First half of 19th century
The Art Complex Museum, Duxbury, Massachusetts 31.26

Handcrafted wooden pails, tubs and firkins were essential to agrarian life throughout New England for many uses. Coopering occupied a substantial amount of Shaker Brothers' time early in the history of several communities, and Shaker buckets grew popular in the outside world.

TWO SPLINT AND HARDWOOD WORK BASKETS WITH BENTWOOD HANDLES

PAGE 66

Black or brown ash splints, hardwood handle and cleats

RECTANGULAR BASKET
25.4 x 46.4 x 35.6cm

ROUND BASKET
38.1 x 33.1cm diam.
Written in ink on underside: *Ministry 1858* and in pencil [illegible]...*H.B.*

New Lebanon, New York, c.last half of 19th century
Hancock Shaker Village, Pittsfield, Massachusetts 71-296.5

These two baskets represent the Church Family basketmakers at Mount Lebanon–the community which produced the greatest number and the finest Shaker work baskets.

COVERED KNIFE BASKET

PAGE 67

Black ash, hickory, brass
25.4 x 26.7 x 18.4cm
Attributed to Mount Lebanon, New York, 1840-1880
Hancock Shaker Village, Pittsfield, Massachusetts 62-181 b

By the mid to late nineteenth century, Shakers were making and selling fancy baskets in their stores. Typically woven by Sisters, these baskets were slow and complicated to produce. The twill work of the tops and the carefully filled in bottoms required a skilled hand and an eye for delicate beauty. The term "knife basket" is a Shaker name, but baskets like these were sold as sewing baskets. The sawtooth edge on this basket is a Victorian feature, added to make the basket prettier and more marketable.

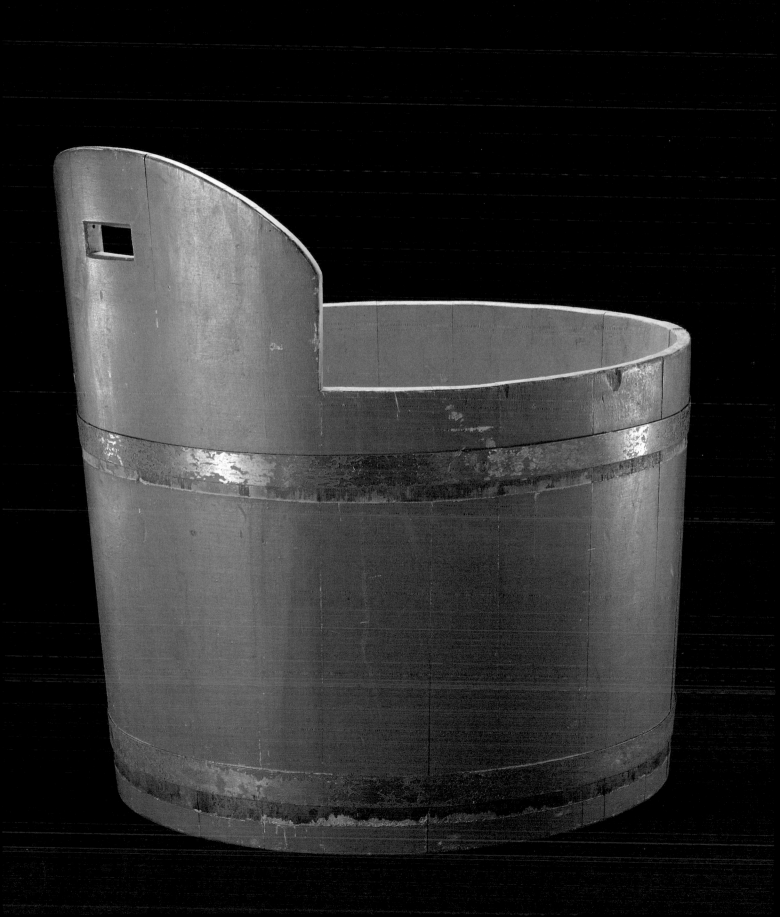

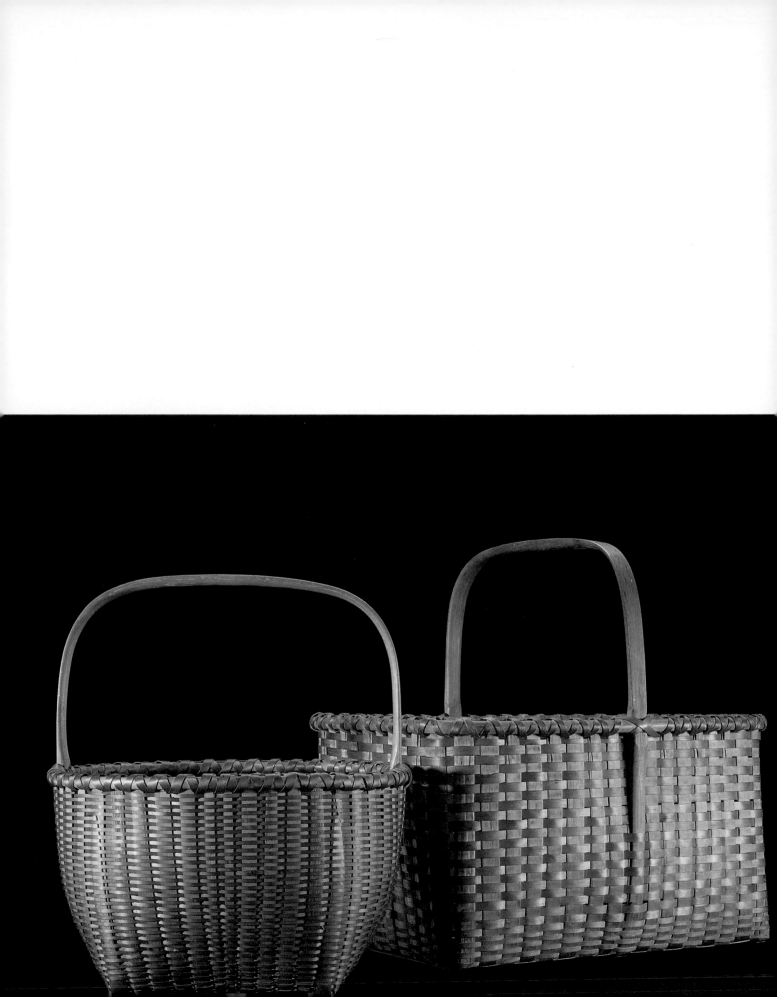

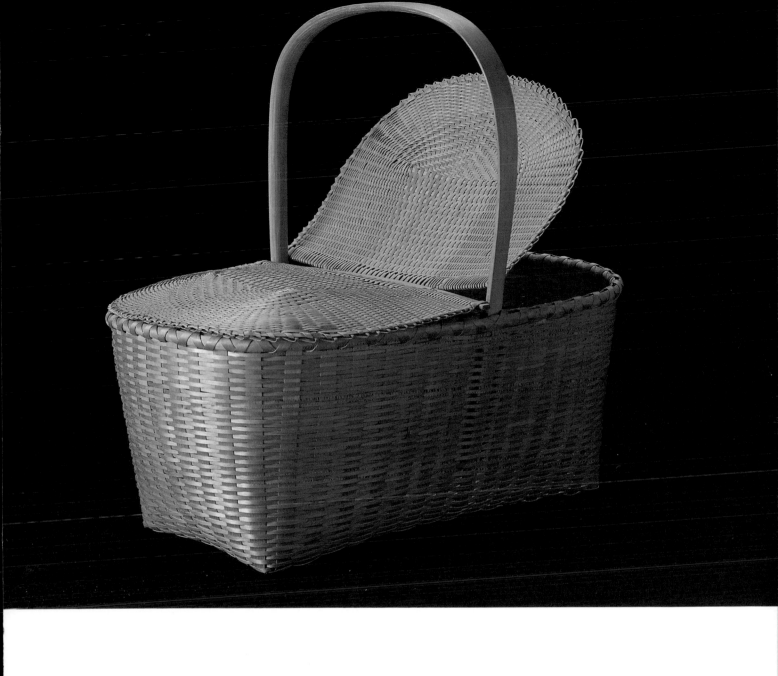

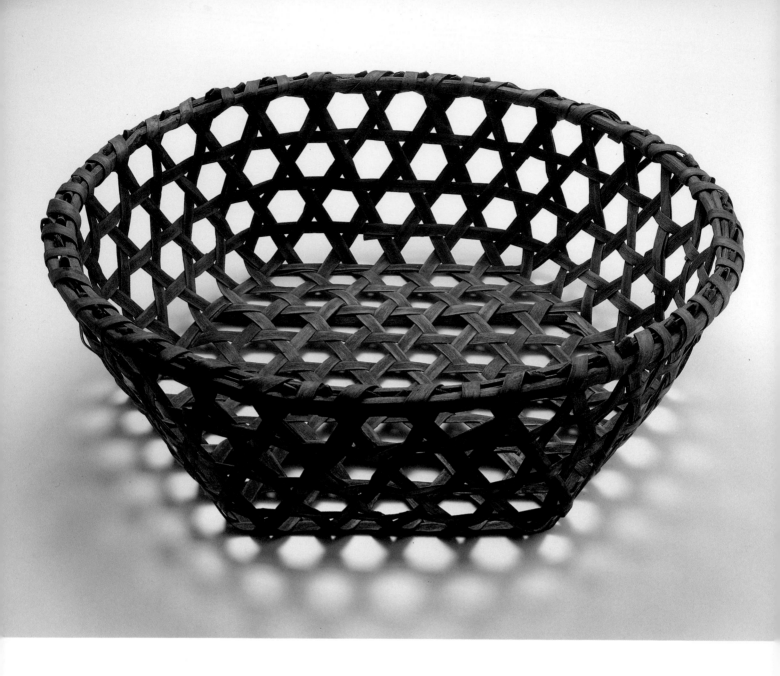

LARGE HEXAGONAL WOVEN CHEESE BASKET

Ash
23.5 x 73.7cm top diam.
Hancock Shaker Village, Pittsfield, Massachusetts, 62.415, Ex Andrews Collection

Strong open-weave baskets such as this—some much smaller, were used
for draining curd and cheese. Cheese-making was a substantial activity in
many Shaker communities, and there are many baskets and woodenware
objects that are associated with the industry.

(Photo from HSV Sezon Catalogue archives)

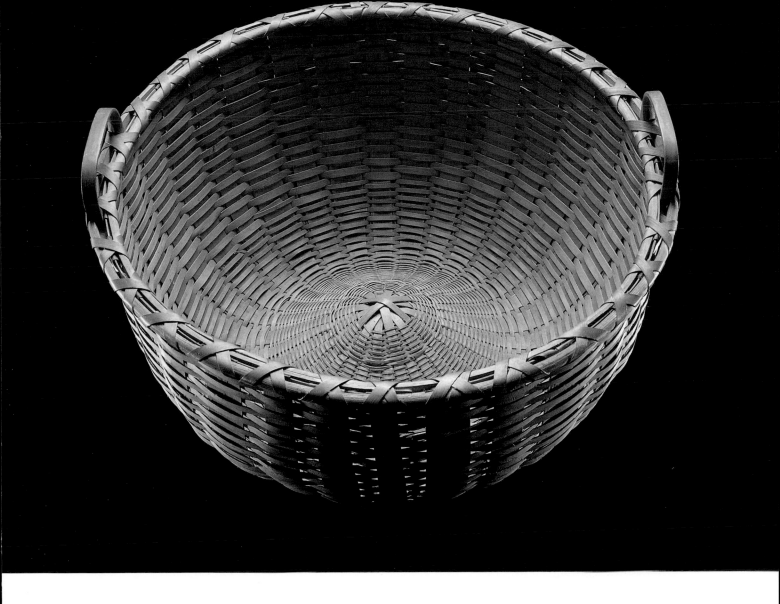

LARGE ROUND UTILITY BASKET WITH SIDE HANDLES

Black ash, dark stain
27.9 x 55.9cm diam.
The Art Complex Museum, Duxbury, Massachusetts 31.27

This basket borrows extensively from the kind of Native American black ash splint baskets in the Taghkanic (Taconic, New York) region that the earlier settlers favored upon arriving in the New World. Popularly they are called "Bushwackers," because they so closely resemble the famous baskets made by families in the hills of Columbia County in New York. They apparently borrowed forms and techniques from the local Native Americans.

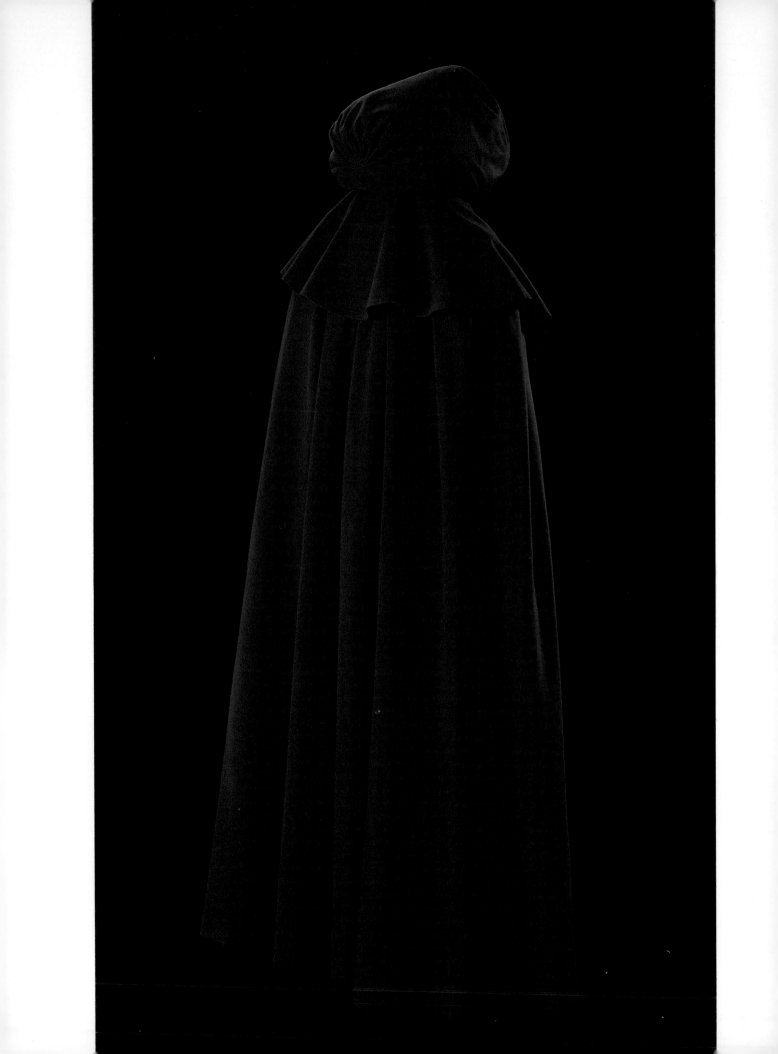

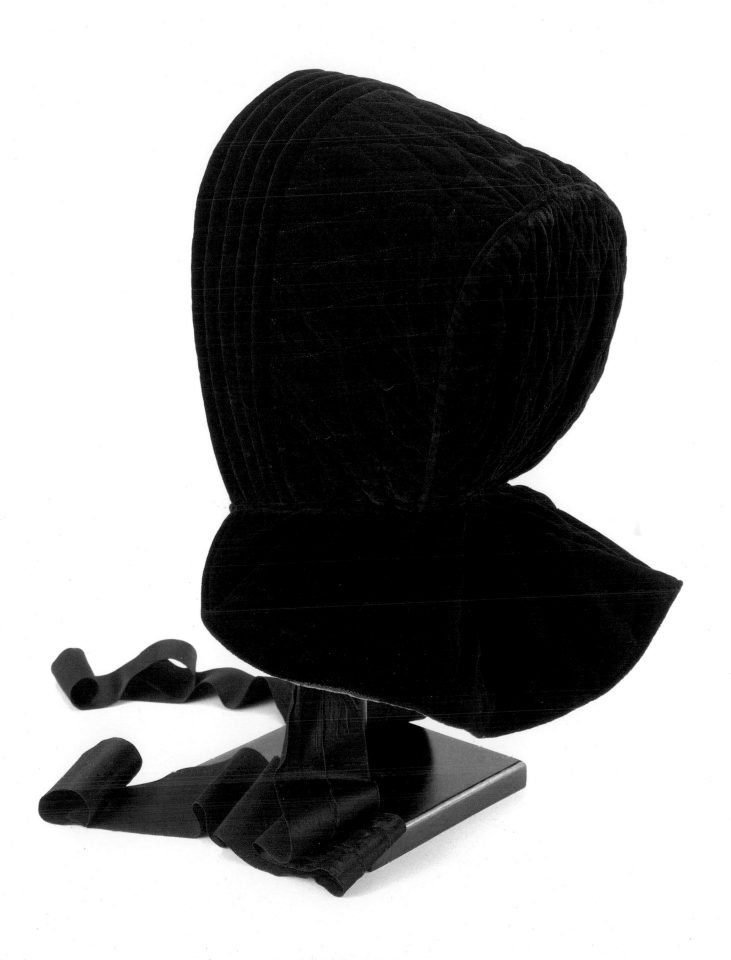

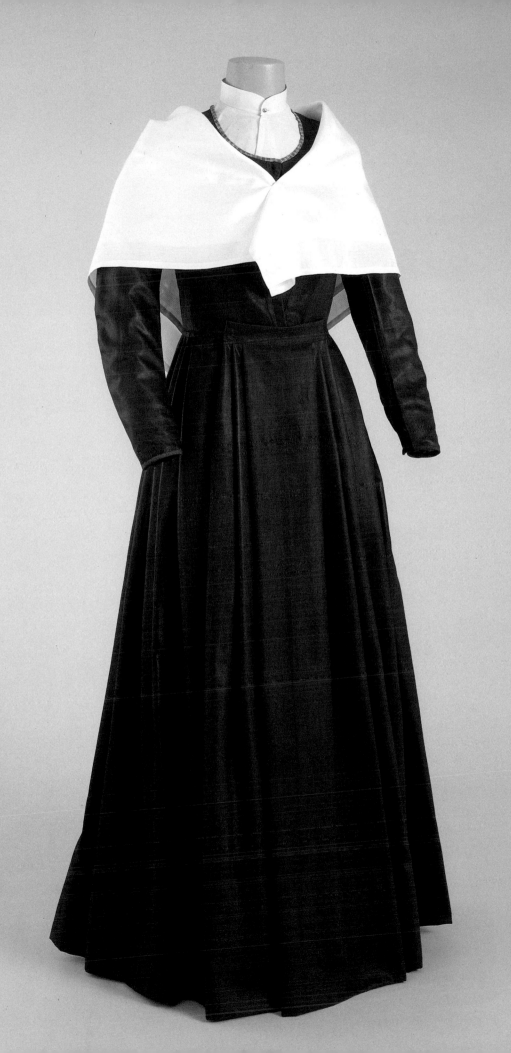

CLOAK

PAGE 70

Red wool broadcloth, red satin hood lining and ties
139.9 (length) x 391.2cm (width at bottom)
c.1850-1925
Hancock Shaker Village, Pittsfield, Massachusetts 75-196.2

QUILTED BONNET

PAGE 71

Silk velvet, silk twill lining, silk ribbons
24.1 x 31.8 x 24.1cm
c.1875-1900
Hancock Shaker Village, Pittsfield, Massachusetts 70-5

Popularly known in the world as the "Dorothy," this type of cloak was named for its designer, Eldress Dorothy Ann Durgin, from the Canterbury, New Hampshire community.

KERCHIEF

PAGE 72

Silk, magenta and bronze dyes, navy blue and green dyes
94 x 97.8cm
In cross–stitch: *JD*
Hancock Shaker Village, Pittsfield, Massachusetts 62-518D

SISTERS' GOWN

PAGE 73

Massachusetts or New Lebanon, New York, c.1875-1900
Glazed wool, cotton lining
144.8 x 61cm
Hancock Shaker Village, Pittsfield, Massachusetts 63-313

As one example of Shaker forerunners of permanent press clothing, the butternut-brown wool of this gown (a popular color for Sisters' gowns and Brothers' trousers) was hand woven and then run through a special press with paper that had been treated with zinc chloride. It then had heat and pressure applied. This process was used both for wool and cotton and produced a fabric that was permanently smooth on one side and resistant to water.

COLLAR

Starched cotton, with rhinestone button in gold colored setting
20.3 x 34.9cm
Cornelia B in brown ink written along bottom of front right side
Hancock Shaker Village, Pittsfield, Massachusetts 73-98.41

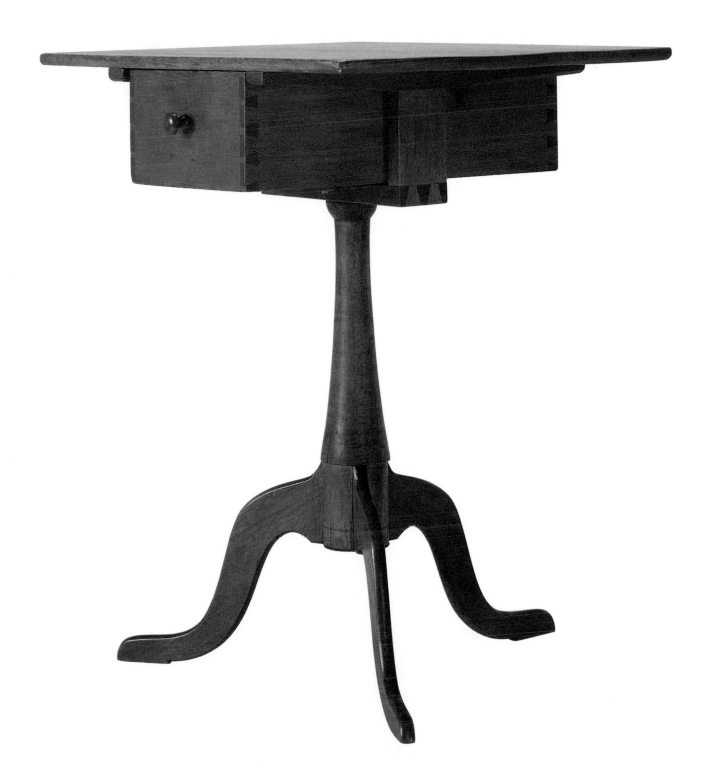

TRIPOD SEWING STAND WITH THROUGH DRAWER PAGE 75

Cherry with traces of red stain, pine drawer, poplar top, beech post, birch
verticals on drawer frame, fruitwood pulls, iron plate at base of post
66.2 x 53.3 x 43.8cm
Attributed to Hancock, Massachusetts, c.1830
Hancock Shaker Village, Pittsfield, Massachusetts 62-15, Ex Andrews Collection

There exist several different kinds of Shaker furniture that have "through" or
two-way drawers, generally signifying use by more than one person. It is
generally belived that two-way drawers are unique to the Shakers. Most
unusual is the combination of six different New England woods in so small
a piece of furniture.

CEILING RACK

Birch rail, white oak hooks, dark red stain
Rail: 4.5 x 177.8 x 3.5cm
Hooks: 14.61 to 22.62 in length
19th century
Hancock Shaker Village, Pittsfield, Massachusetts 81-53

This novel and curious ceiling rack is, so far as is known, a one-of-a-kind
object. It was found installed in the Brethren's Shop at Hancock.

FIVE-ARM CLOTHES HANGER

White pine, stain, copper tacks
70.5 x 40 x 1.3cm
Attributed to Hancock, Massachusetts, 1860-1880
Hancock Shaker Village, Pittsfield, Massachusetts 62-344, Ex Andrews Collection

It is generally believed that clothes hangers with multiple arms are unique
to the Shakers. They were probably used in communal laundries for ironed
clothing.

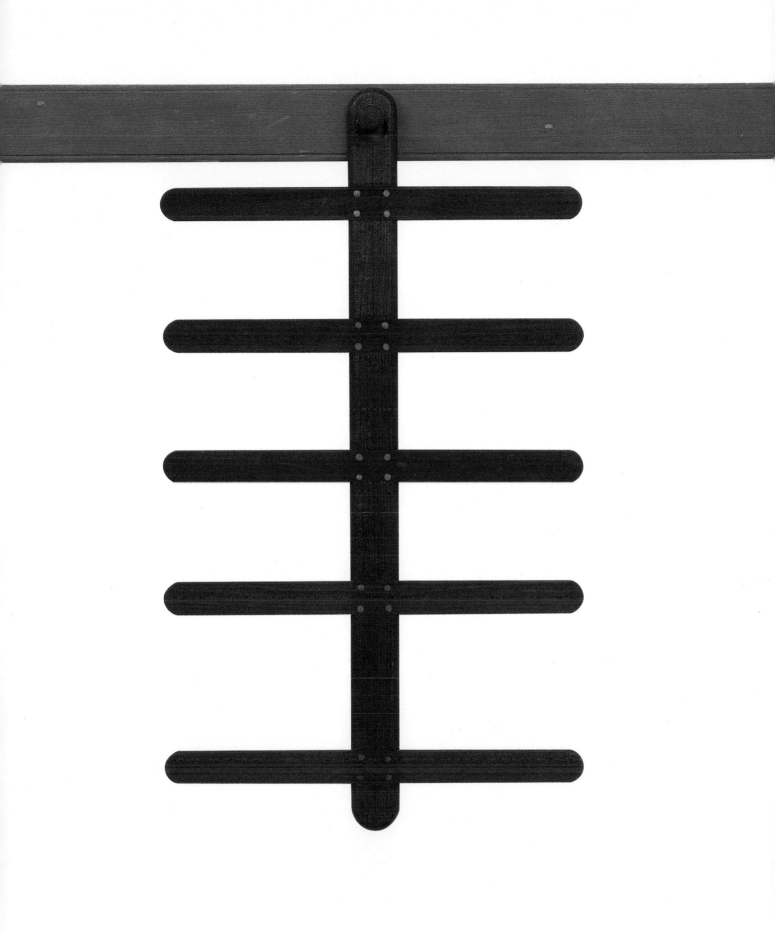

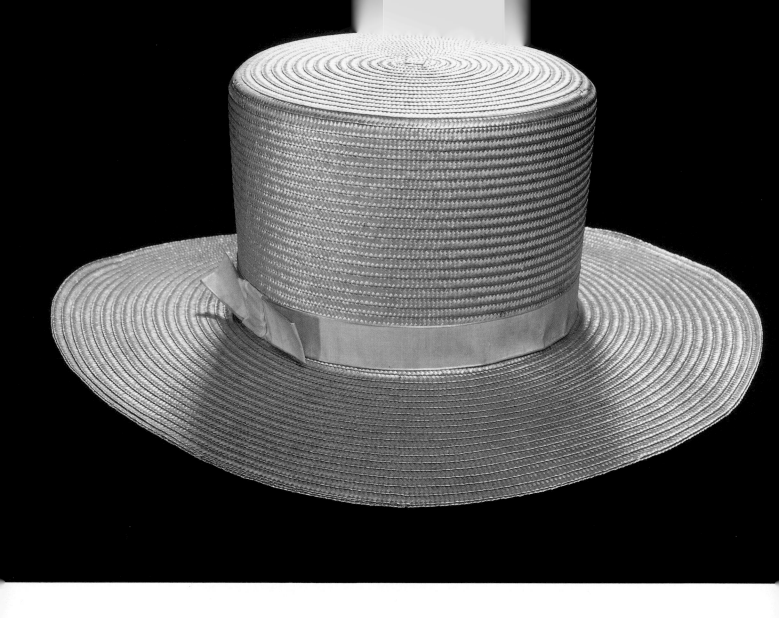

BROTHER'S HAT

Braided straw, cotton net, paper, silk ribbon
12.7 x 38.7 x 37.5cm
In pen on inside of crown *DANIEL OFFORD, MT. LEBANON 1873*
New Lebanon, New York
The Western Reserve Historical Society, Cleveland, Ohio 2463, Ex Cathcart Collection

"...the broadest of all broad-brimmed hats" remarked Charles Dickens disapprovingly, about the Brothers' hats after a visit to New Lebanon in 1842.

Just as the Sisters changed from straw or palm-leaf bonnets in winter, the Brothers put away their hats such as this in favor of wool-felt or fur hats. This hat is one of a few of its type that have survived and bears the name of its maker, Daniel Offord, 1873, at which time he would have been about 30 years of age.

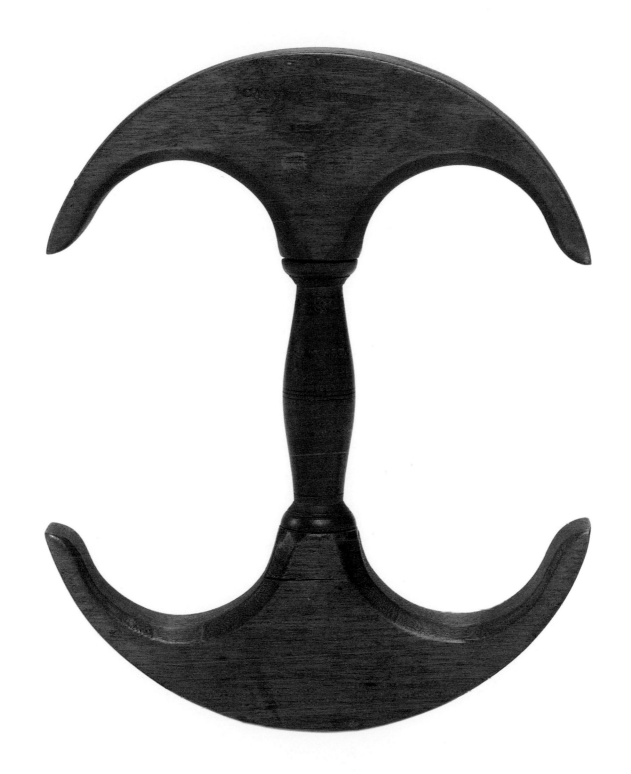

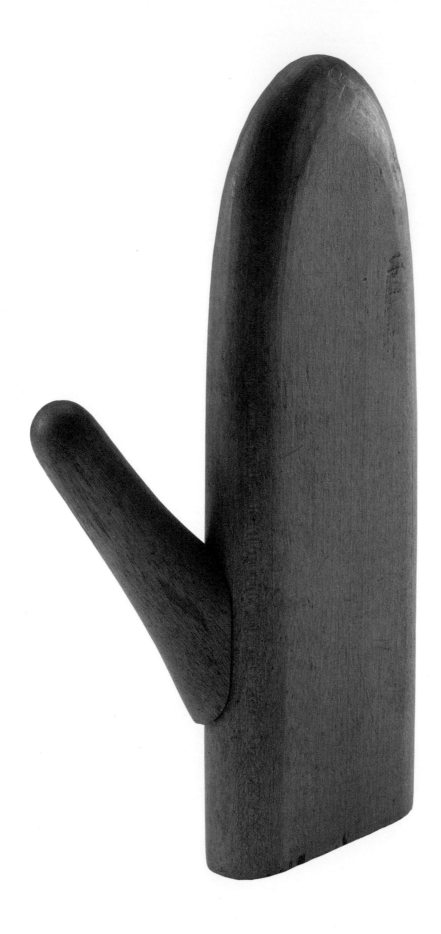

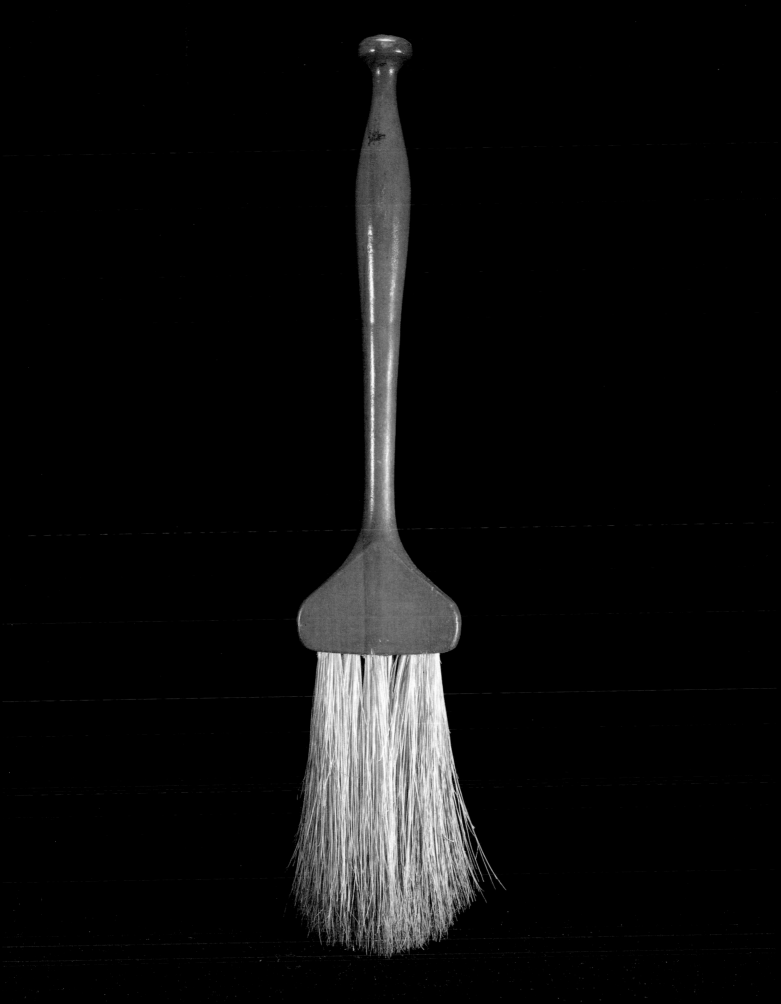

HAT FORM

PAGE 79

Birch, stain
17.5 x 14 x 2.2cm
Stamped on one end: *CALVIN REED 1837*
Stamped inside threaded section: *AN*
Attributed to Samuel Humphery Turner, New Lebanon, New York, 1837
Hancock Shaker Village, Pittsfield, Massachustts 71-172.A, Attributed to Andrews Collection

This finely detailed wooden mold was used to hold in place the deep
crowns of Brothers' hats when not being worn.

MITTEN FORM WITH SEPARATE THUMB FORM

PAGE 80

Maple and yellow birch
22.5 x 12.4 x 1.9cm (overall, when assembled)
62-716.6 (mitten) & 62-716.7.5 (thumb)
c.1800-1850
Hancock Shaker Village, Pittsfield, Massachusetts, attributed to Andrews Collection

Sisters used wooden forms to shape mittens knitted of woolen yarn. The
thumbs are detachable to slip easily into place. The process of shaping
lightly dampened knitted garments is called blocking.

BRUSH

PREVIOUS PAGE 81

Hardwood, stain, varnish, horsehair
29.8 including horsehair x 4.5cm
Hancock Shaker Village, Pittsfield, Massachusetts 62-663 a, Ex Andrews Collection

This is thought to be a hat brush. The holes near the end were possibly for
a leather loop.

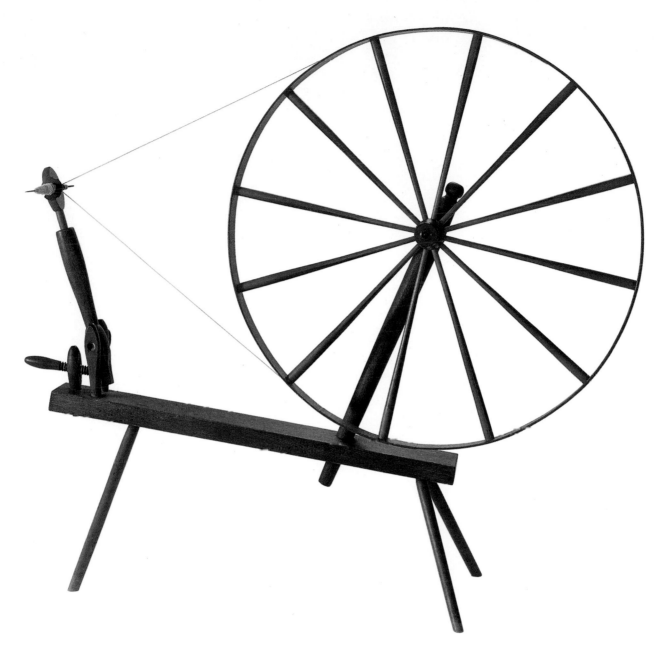

SPINNING WHEEL

Birch, red oak, white oak, maple, stain, leather, twine, iron
151.8 x 175.3 x 61cm; 109.2cm wheel diam.
E.A. in paint on the bathead
Attributed to New Lebanon, New York, 1800–1840

Hancock Shaker Village, Pittsfield, Massachusetts 68–121, wheel, and 68–121A, bathead
Ex Upton Collection

Since the Sisters had to walk back and forth in spinning woolen
yarn on these large wheels, they became known as "walking
wheels." This wheel was used in this century by Sister Jennie Wells
who lived in the Shaker communities of Groveland and Lebanon,
New York and Hancock, Massachusetts.

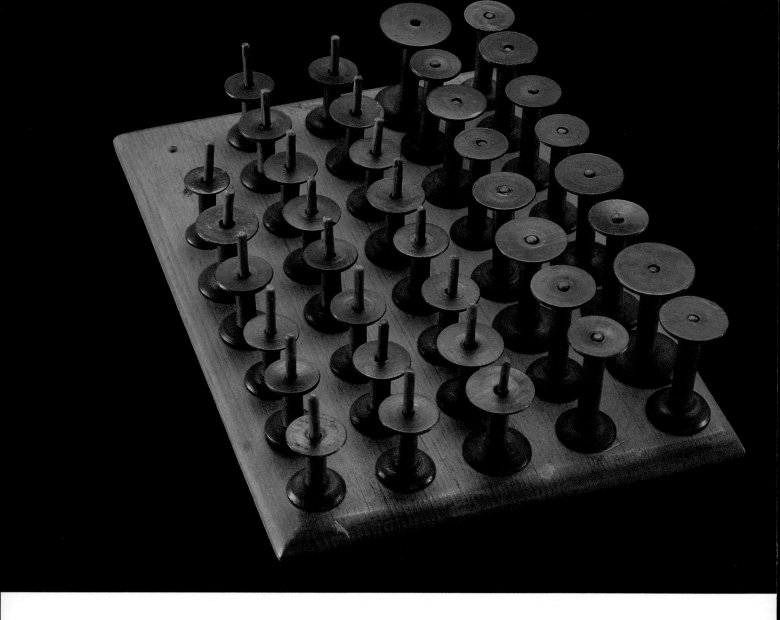

SPOOL RACK AND SPOOLS

White pine, birch, yellow and red stain
Size of rack 3.8 x 12.7 x 17.8cm
LEVI STEVENS MADE THIS in ink on bottom
The Church Family, Canterbury, New Hampshire, 1825-1850
Hancock Shaker Village, Pittsfield, Massachusetts 62-312, rack; 64-326 a-ll, spools
Ex Andrews Collection

Brother Levi Stevens was a master wood turner at Canterbury, New
Hampshire, who worked in the turning mill and in making wooden pails.
There are thirty-eight spools in three sizes, and only a skilled wood turner,
with patience, could have produced so finely turned and graded a set of
such miniatures. The yellow rack and the red spools combine the colors
favored by the Shakers.

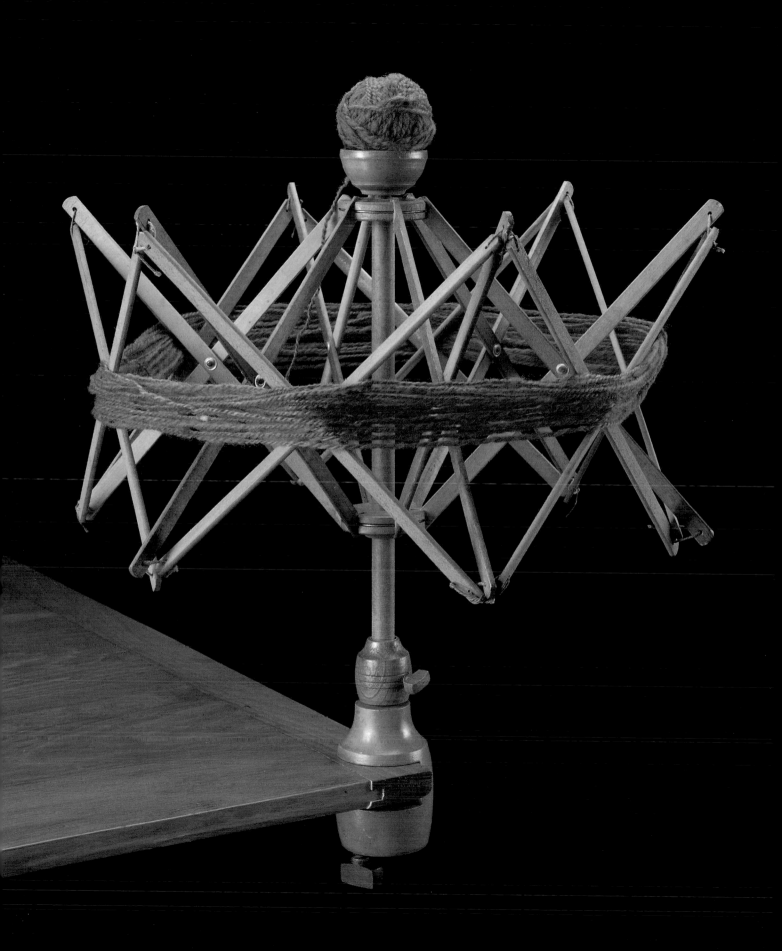

TABLE SWIFT PAGE 85

Maple, birch, beech, yellow stain, tin, iron, thread
47 x 8.9 x 81.3cm diam. fully extended
Hancock, Massachusetts, c.1850-1860
Hancock Shaker Village, Pittsfield, Massachusetts 71-178c

Though not their invention, the Shakers at Hancock made and sold thousands of table swifts between 1850 and 1860. This collapsible swift attached to a table base and expanded like an umbrella to full size, as shown

TAPE LOOM

Fruitwood, iron
38.1 x 13.3 x 1cm
1800-1830
Hancock Shaker Village, Pittsfield, Massachusetts 71-160

Shaker Sisters, like most American women, wove narrow cloth tapes for household uses, including ties for sacks and garters for tying stockings at the knee.

RAG CARPET PAGE 88

Blue, green and white cotton; blue, green, white, red cotton tape
190.5 x 120.1cm
Last half of 19th century
Hancock Shaker Village, Pittsfield, Massachusetts 63–301
Ex Andrews Collection

The Shakers' preferred floor covering was a narrow woven carpet that quieted footsteps, protected the floorboards, and was easily rolled up and removed for cleaning (by beating out the dust outdoors). This kind of carpet, called a rag carpet because it was thriftily made from strips of worn clothes or bedding, was a typical home-made floor covering in nineteenth century America.

THIRTEEN SAMPLES OF CHAIR TAPE PAGE 89
Wool, linen
Varying in width from 1.7 to 3.2cm
1830-1860
Hancock Shaker Village, Pittsfield, Massachusetts 79-82

By the 1830s the Shakers were beginning to use cloth tape to make chair seats—colorful, comfortable, durable and easier to install than the traditional rush, splint or cane, which they also used.

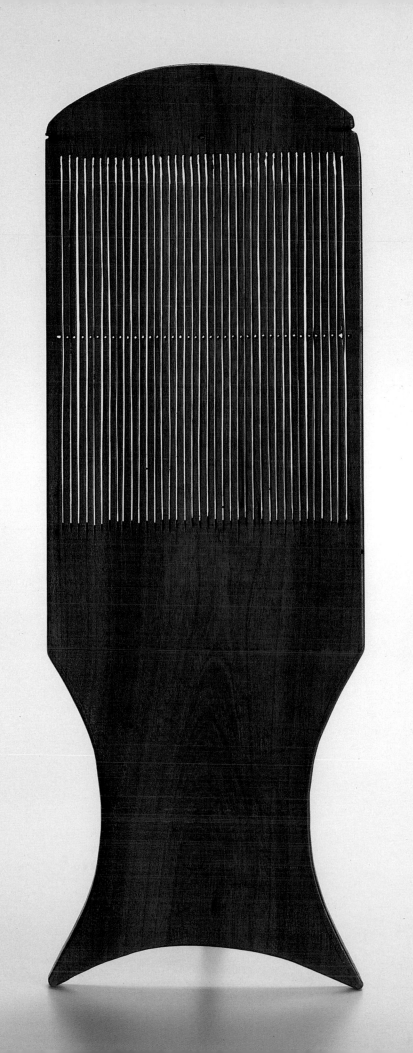

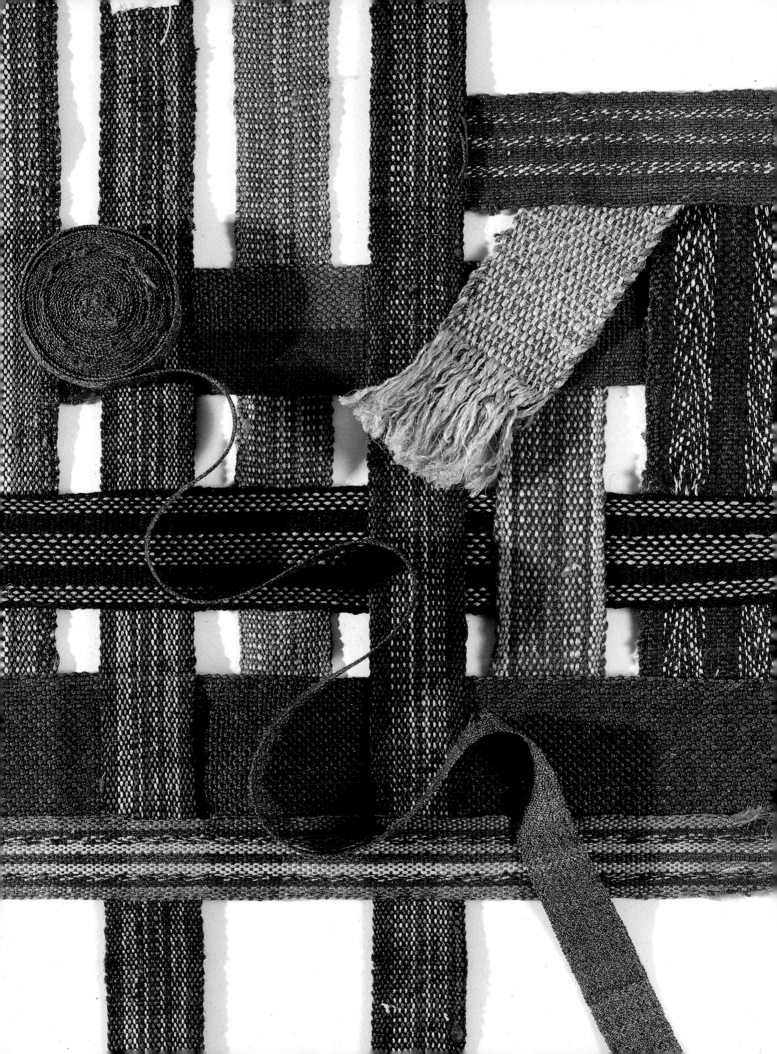

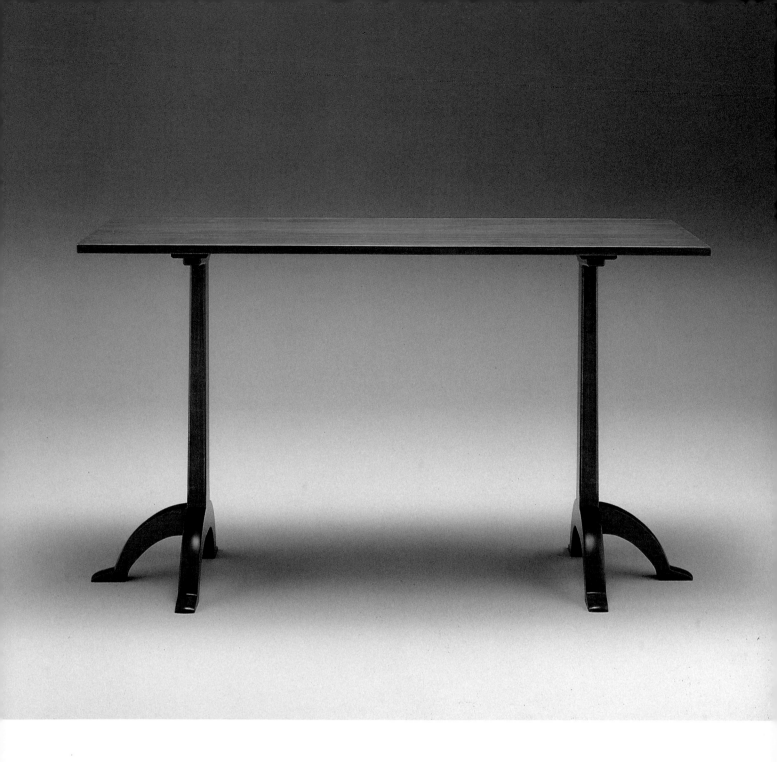

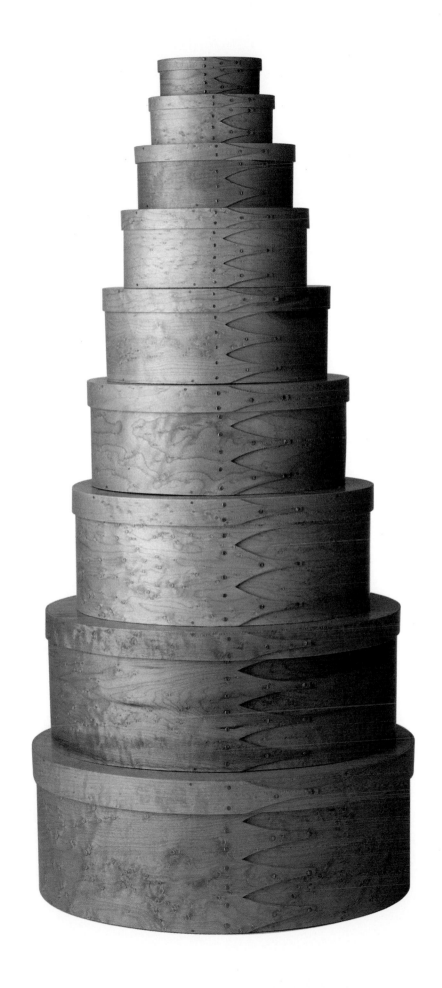

SERVING TABLE

PAGE 90

Maple, stain, varnish
74.9 x 128.9 x 50.8cm
Shaker Workshops, Concord, Massachusetts, 1994
Loaned by Shaker Workshops, photo courtesy Shaker Workshops

Shaker Workshops in Concord, Massachusetts specialize in the reproduction of Shaker pieces in museum and private collections. This table is a reproduction from an original at Hancock Shaker Village in Pittsfield, Massachusetts. The arched legs are common on the trestle tables Shakers used for dining, but the third foot on each of the trestles is unusual.

OVAL BOXES

PAGE 91

Paul Dixon

Birdseye maple, alder, maple, copper tacks, oil and wax finish
Nine sizes from 3.4 x 9.8 x 6.1cm to 14.5 x 37 x 28cm
Stamped *ORLEANS CARPENTERS*
Orleans, Massachusetts, 1994–1995
Loaned by the artist

Paul Dixon's oval boxes are among the most popular reproductions of Shaker fingered boxes in New England. Most of his forms are based on traditional Shaker lidded, deep boxes and shallow "button" boxes as well as on oval carriers. While the majority of his bentwoods are made of cherry, he has developed exceptional skill in handling the more difficult and unpredictable maple known as birdseye, a modern variation on the woods commonly used by the Shakers.

TWILLED TUB FORM BASKET

Black ash splint and handles, birch rim
7.5 x 28.5cm top diam.
Gerrie Kennedy, Pittsfield, Massachusetts, 1992
Loaned by the artist

This intricate basket is a slightly modified reproduction of a Shaker twilled tub in the collection of the Shaker Museum and Library at Old Chatham, New York. For many years basket maker Gerrie Kennedy has studied and taught the techniques of Shaker basketry, specializing in distinctive "fancy" weaves such as this tub.

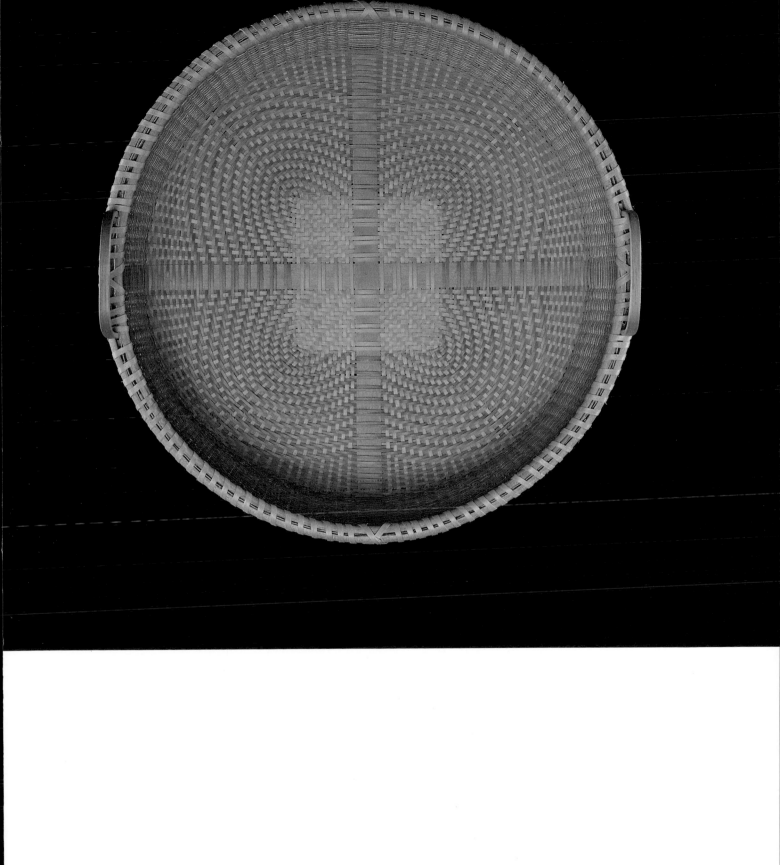

STORAGE CHEST ON WHEELS *(Kuruma–dansu)*

Zelkova *(keyaki)*, cryptomeria *(sugi)*, lacquer, iron
94.3 x 112.7cm
Yonezawa, in modern Yamagata Prefecture
Meiji Period, late 19th-early 20th century
The Brooklyn Museum, Brooklyn, New York 75.126

Wheeled chests of this type were used for storage and to move materials between a residence or shop and a storage building or to move things quickly and safely in case of fire-an ever-present danger in older quarters of Japan. Such large chests are heavy and awkward to move since the wheels do not rotate on their axles. At one point they were banned from the narrow streets because they prevented evacuation and access to a blaze by firemen.

The dramatic grain of *keyaki* has made it one of the woods most prized by the Japanese for furniture and other items of wood. It has been used extensively in this storage chest, including the frame and front sliding panels. The top, sides and back are of *sugi*.

Yonezawa is famous for the production of chests in the late Meiji Period.

94

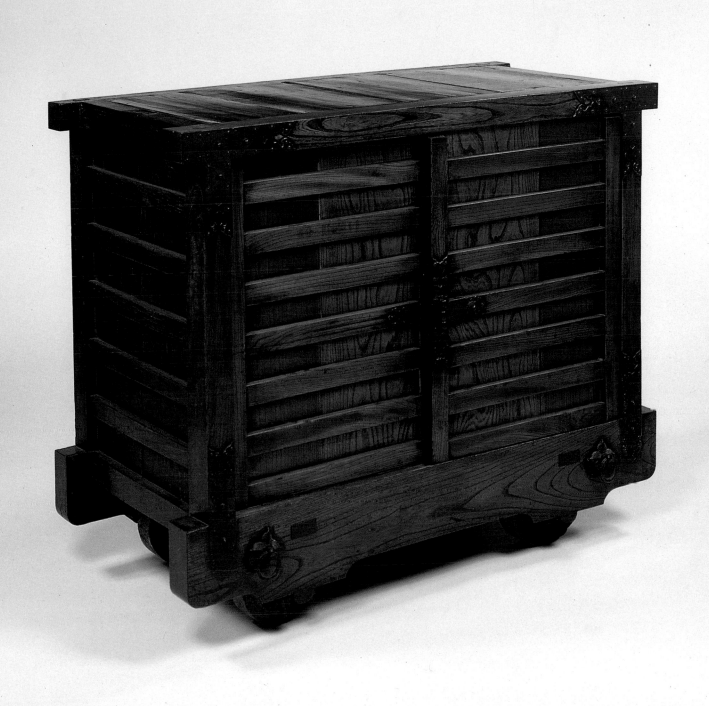

STAIRWAY CHEST *(Kaidan–dansu)*

Frame: cypress *(hinoki)*, drawer faces: zelkova *(keyaki)*, and treads: cryp-
tomeria *(sugi)*, lacquer, iron
198.1 x 112cm
Kawagoe, in modern Saitama Prefecture
Late Edo-early Meiji Period, 19th century
The Brooklyn Museum, Brooklyn, New York 77.142

Fully enclosed staircase chests such as this were used extensively in
Japanese homes, shops and storehouses and were found in urban and
rural settings. The woods and construction of this free-standing chest-stair-
case are light enough that it can be moved to various openings to an upper
floor.

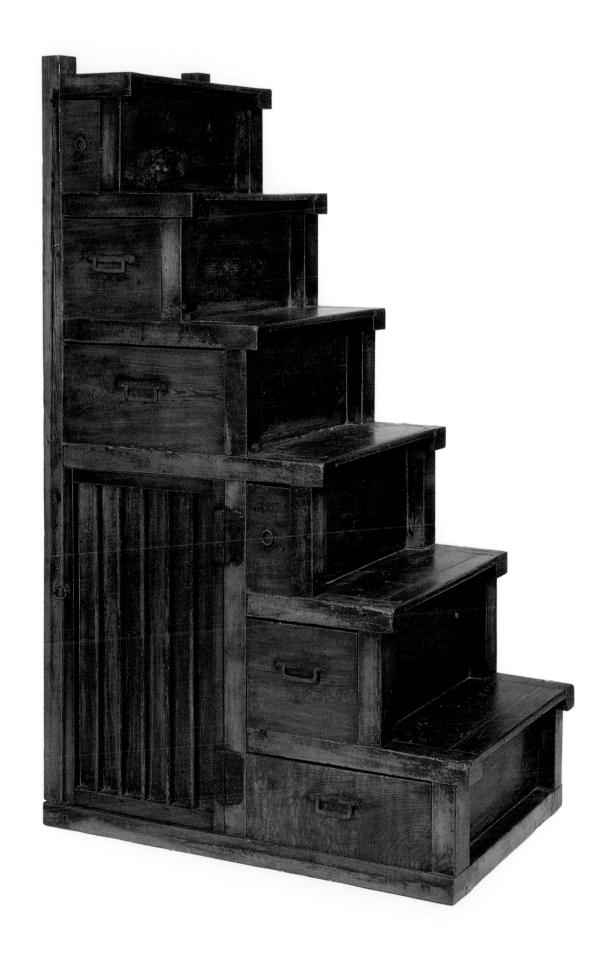

KITCHEN STACKED CHEST *(Mizuya Kazane–dansu)*

Cypress *(hinoki)*, cryptomeria *(sugi)*, zelkova *(keyaki),* lacquer, copper, iron
162.5 x 110.5 x 40.6cm
Attributed to Hikone, in Shiga Prefecture, Meiji Period
Collection, Judith Dowling, Edo Gallery, Boston, Massachusetts photo; Joe Green

Chests designed for kitchen and pantry use could contain large quantities
of stacked dinnerware, serving dishes and food. The refined and simple
features of this small, two-part chest are characteristic of those from
Hikone, particularly the slatted front panels affixed by rows of copper nails.
Mizuya-dansu are frequently designed in two sections for ease of moving.

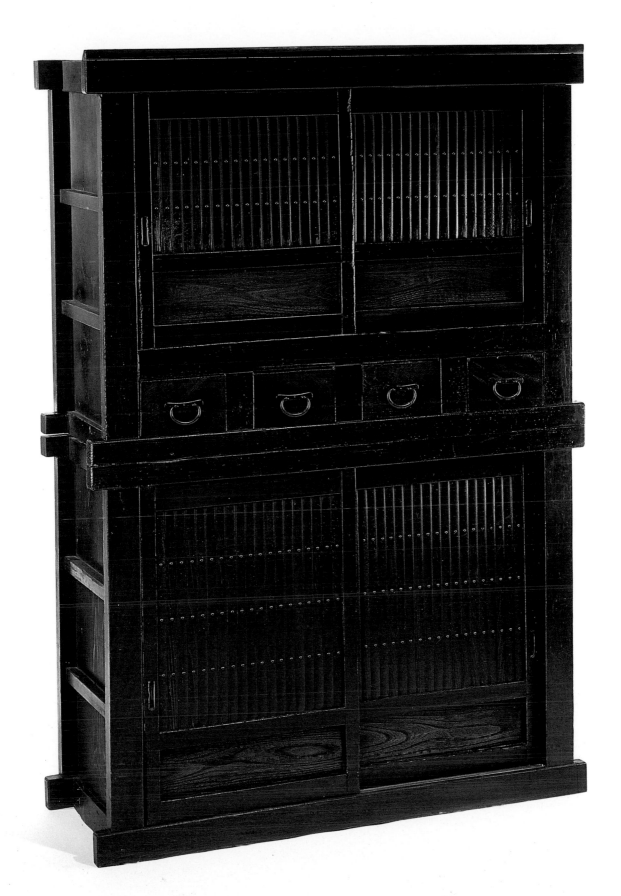

SEWING CHEST *(Hari Bako)*

Mixed woods, lacquer, brass
48.2 x 22.2 x 24.3cm
Attributed to Taishoo Period
Mingei International Museum 1983-13

Sewing boxes like this were popular during the Meiji and Taishoo Periods, and are identified by the Japanese word for pin or needle, *hari.*

LOCK AND KEY *(Jo)* PAGE 102

Iron
10.8 x 15.4 x 7.3cm
Attributed to late Shoowa, Early Meiji Periods
Collection, Isamu Kawaguchi

This lock combines a traditional Asian feature in the bar fastener with a key that is Western in style. This style of lock, depending on its strength, was used to secure store houses and certain chests.

SEA CHEST *(Funa-dansu)* PAGE 103

Zelkova *(keyaki),* iron
47.5x38.9 x 44.5cm
Mido Edo period
The Peabody Museum, Salem, Massachusetts E14701

Sea chests with a single door are called *kakesuzuri* and evolved from small chests used on land. Frequently called "safes," they were used to safe-guard money, documents and similar valuables at sea. This chest is made of thick Zelkova, and the sorners and seams are reinforced with metal. The hand-cut iron work reinforcing the front has incised decorations of pine, Bamboo and plum—a traditional design known as "three friends."

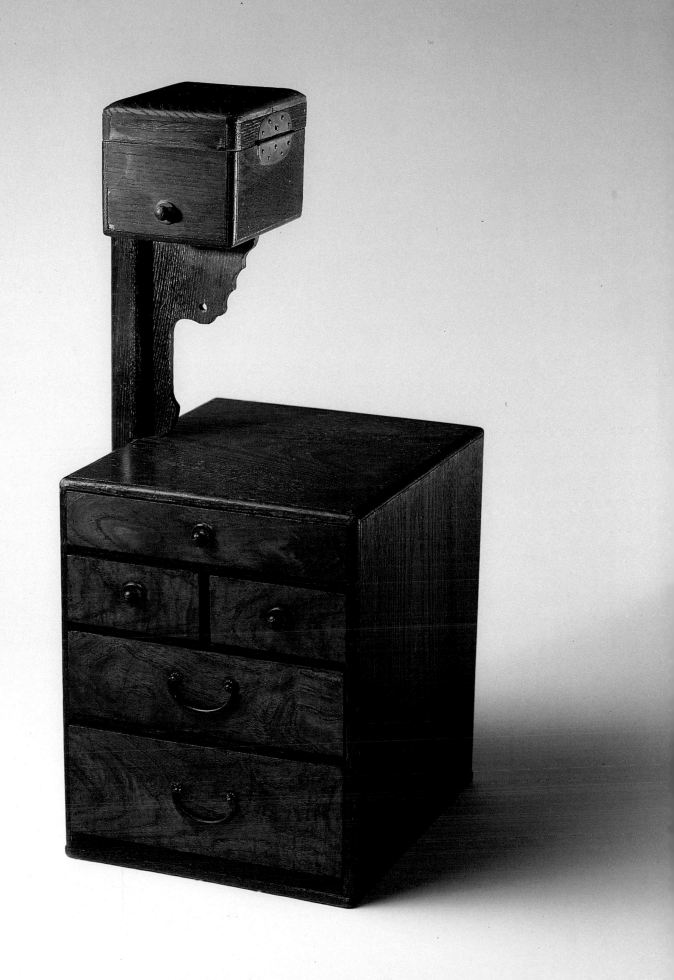

FOLDING CANDLESTICK *(Kaichu Shokudai)*

Brass
33.6cm
Original design attributed to Tanaka Hissae
Meiji Period, c.1880
Collection, Isamu Kawaguchi

This candlestick was designed for travel use. This explains its Japanese name which means a candlestick to fold and put inside the front of one's garment. Frequently associated with surveyors, such portable candlesticks became popular and were produced in great numbers. The three hinged sections of the upright can be lowered and adjusted in many directions without disturbing the balance.

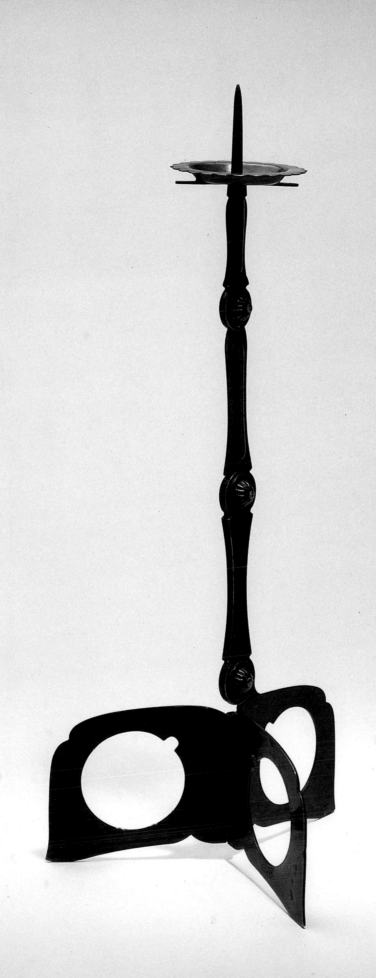

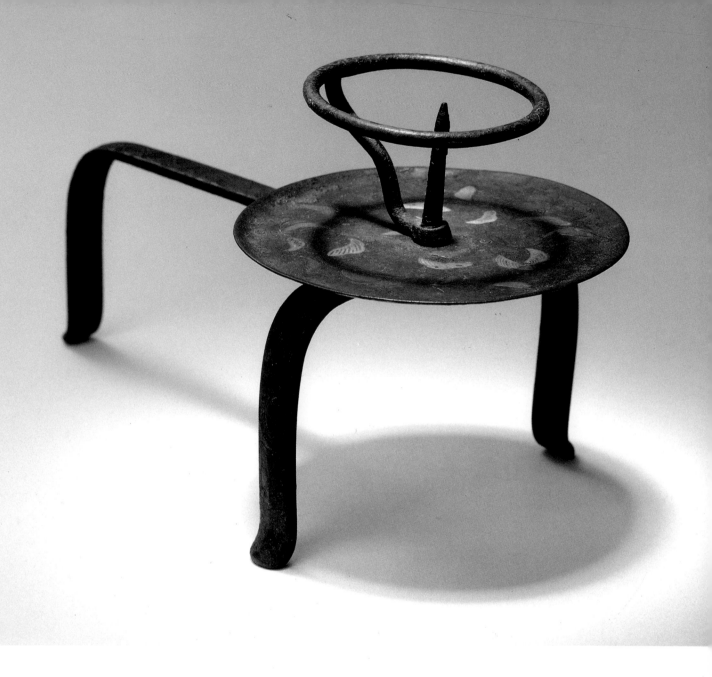

FOOTED CANDLESTICK *(Teshoku)*

PAGE 106

Iron, silver inlay
Height 14cm
The Peabody Essex Museum, Salem, Massachusetts E24932

Such candlesticks, easily carried by the long handle which serves also as a third foot, customarily had a cone-shaped piece of paper that was fitted around the candle inside the ring and flared at the top, creating a shade. This candlestick would be quite common except for the delicate pattern of leaves inlaid in silver on the top of the handle.

APOTHECARY MORTAR *(Yangen)*

PAGE 107

Iron, wood
Mortar: 43.5 x 15.2 x 18.4cm
Wheel: 23cm diam.
Not later than 1913
The Peabody Essex Museum, Salem, Massachusetts E15760

Boat shaped mortars such as this made of wood were used by apothecaries for cutting and grinding components of herbal medicine into digestible powders: leaves, seeds, roots, and bark. Heavier iron yangen, like this one of cast iron, were used to grind ingredients such as bone and antler. The opening at the left allows the contents to be emptied.

ADJUSTABLE KETTLE HANGER *(Jizai Gake)*

OPPOSITE

Iron
172.2cm length fully extended
Meiji Period, before 1909
The Peabody Essex Museum, Salem, Massachusetts E12,066

Long adjustable hangers for suspending kettles and pots over open charcoal hearths were standard in most Japanese homes well into this century; and many traditional homes still employ them. They exist in a myriad of shapes and lengths, but the principles are similar. This piece is composed of two long, flat iron rods, one of which is hung from a beam in the open ceiling, the other of which is adjustable, allowing a vessel to be raised or lowered near the charcoal. When a pot or water kettle is hung from the lower hook, the cross piece *(yokogi)*–here in the shape of a fish, pulls the narrow iron bamboo branch against the fixed rod, creating sufficient tension to hold the movable rod securely in place.

ADJUSTABLE KETTLE HANGER *(Jizai Gake)* OPPOSITE

Bamboo, zelkova *(keyaki)*, iron
266.7 x 63.5cm
Early Meiji Era
Collection, Millicent and Herbert Brill

The crosspiece of zelkova wood is in the shape of the Japanese character *ichi*, meaning "one."

DOCUMENT BOX *(Bunko)* PAGE 112

Cherry bark *(zakura kawa)*
6.9 x 33.4 x 24.2cm
Attributed to Toohoku Region
Late Shoowa Period
Private Collection

Objects made from or covered with the bark of mountain cherry *(yamaza-kura)* have been made in the Toohoku Region of northern Honshuu for hundreds of years. Mostly associated with utilitarian objects, there are important pieces in the imperial treasury at Nara that are more than twelve hundred years old.

The mountain cherry is known for its strength and resistance to humidity. The bark is removed by licensed collectors who take only a thin sheet, allowing the tree to produce a new layer. Though popular throughout Japan, Akita Prefecture is most famous for this work.

PAIL *(Baketsu)* PAGE 113

CYPRESS *(hinoki)*, cherry bark
27.8 x 24.1cm diam.
Attributed to Hinoemata Village, Fukushima Prefecture, Late Shoowa Period.
Private Collection

This bentwood pail is typical of Hinoemata, a village in the Toohoku Region of Japan. The cedar has been soaked, then bent around a form and secured by a lacing of cherry bark, which also forms the loops for holding the separate handle.

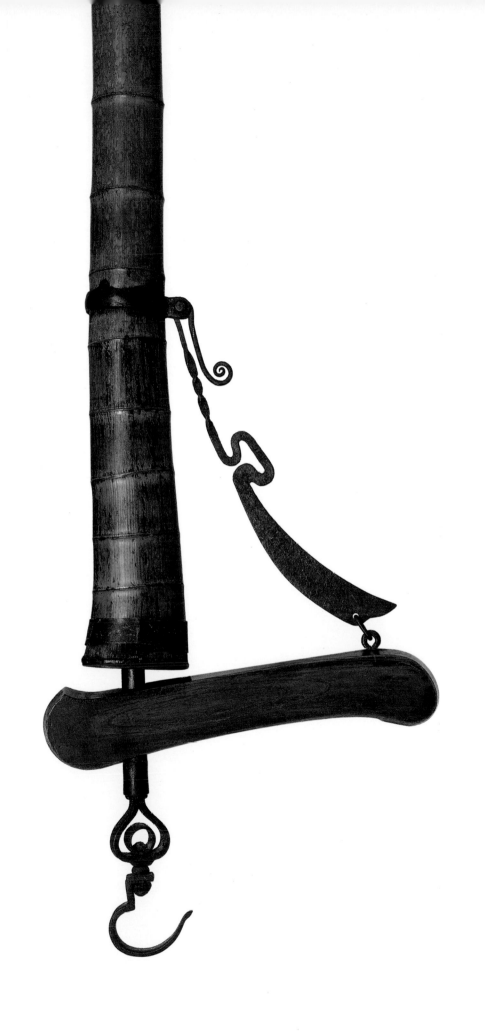

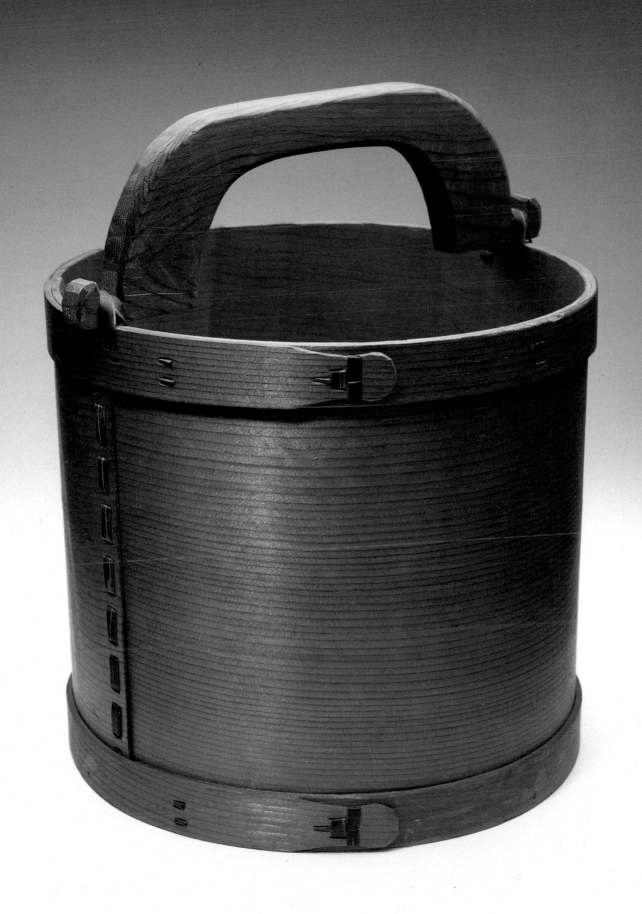

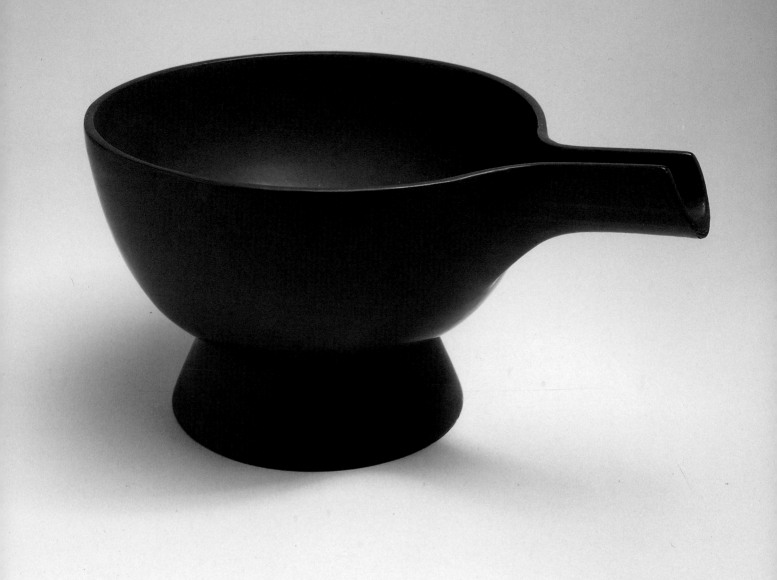

LIPPED BOWL *(Katakuchi)*

Wood, lacquer
19 x 71.7cm diam.
Attributed to Wajima, Ishikawa Prefecture, Edo Period
Private Collection

Such a footed bowl with a prominent spout is used for serving *sake* on cer-
emonial occasions. Red is a color used for happy occasions such as wed-
dings. Wajima, on the Noto Peninsula, has long been famous for lacquer
and, particularly, for this type of bowl.

FRAMED LANTERN *(Andon)*

Wood, lacquer and handmade paper *(washi)*, brass
99.6 x 32.2cm diam.
Edo Period
Private Collection

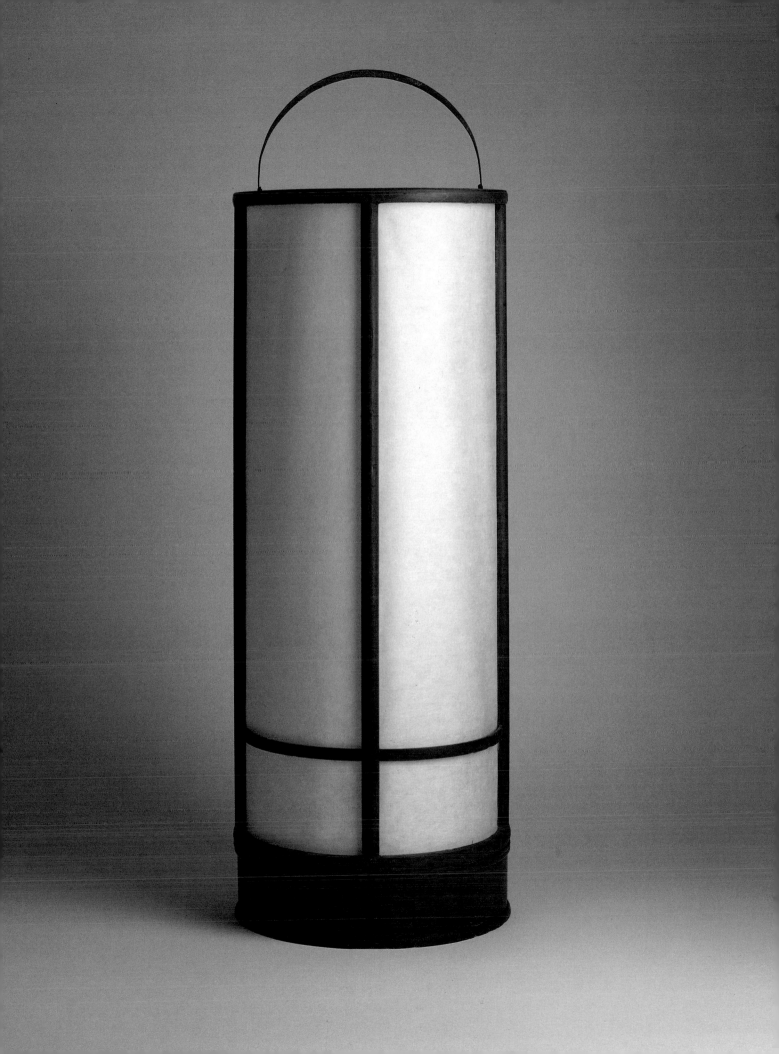

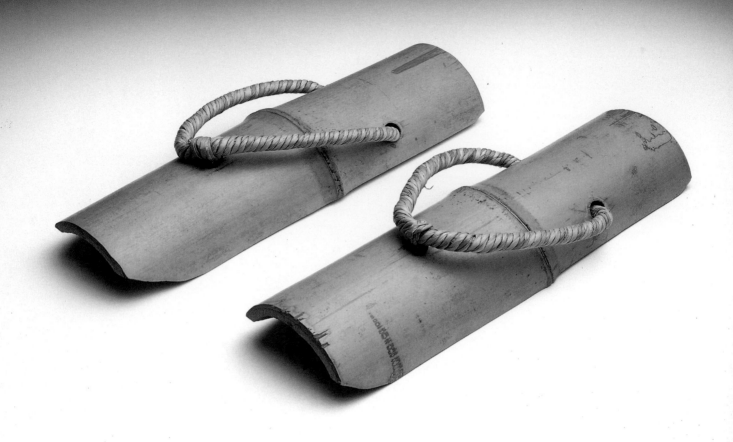

SANDALS *(Geta)*

Bamboo, straw
5.8 x 26.6 x 9cm
Late Shoowa Period
Private Collection

Sandals cut from half-round sections of bamboo are used traditionally in the tea garden by the host or hostess.

TEA WISK *(Chasen)*

10.5 x 5cm top diam.
Chasen Mura (Chasen Village), Nara Prefecture, 1994
Loaned by Kiyoshi Ota, Shiga

For many people such exquisitely cut bamboo tea wisks as this one represent the ultimate in beauty and skill in a utilitarian object.

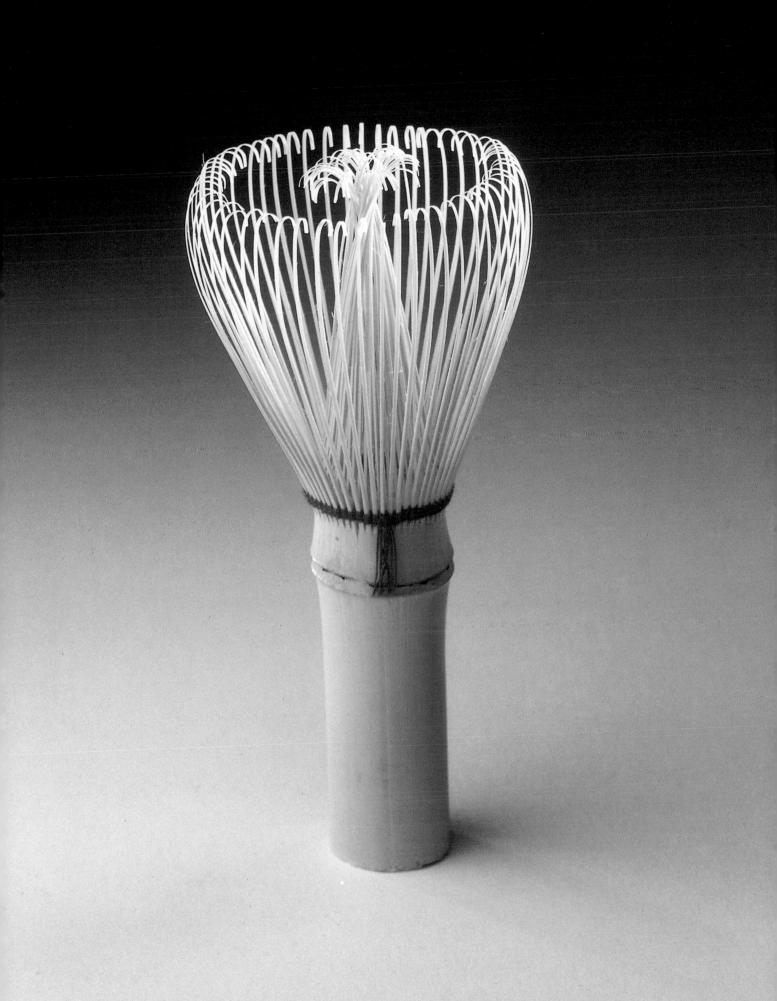

FAN *(Uchiwa)* PAGE 119

With stencil work by Keisuke Serizawa
Bamboo, handmade paper *(washi), colors*
41.2 x 28cm diam.
Late Shoowa Period
Private Collection

CREEL *(Shitami)* PAGE 120

Bamboo
21.8 x 17.5 x 23cm
Mid-to-late Edo Period, not later than 1806
The Peabody Essex Museum, Salem, Massachusetts E2608, Ex Morse Collection

Though a common basket form, this creel is superb both in design and weaving. The transformation of the form from rectangle at the bottom to oval and then to circle occurs imperceptibly. Creels, used both for net and rod fishing, are tied around the hips so the creel can remain in the water, keeping the catch fresh.

LIDDED TRAVELLING BASKET PAGE 121

Cane, wood, iron, leather
76.5 x 43. x 38cm
Meiji Period, before 1890
The Peabody Essex Museum, Salem, Massachusetts E3067, Ex Morse Collection

This remarkable basket has remained in excellent condition even with substantial use. The delicate shape and lightweight appearance belie its strength. The detachable lid fastens on the back with iron hooks and in the front with a hasp. On the back of the basket is a large wooden frame with leather shoulder straps, indicating it was carried on a person's back.

BASKET *(Kago)* PAGE 123

Bamboo
20.9 x 51.4cm top diam.
Late Shoowa Period
Attributed to Oita Prefecture, Kyuushuu
Private Collection

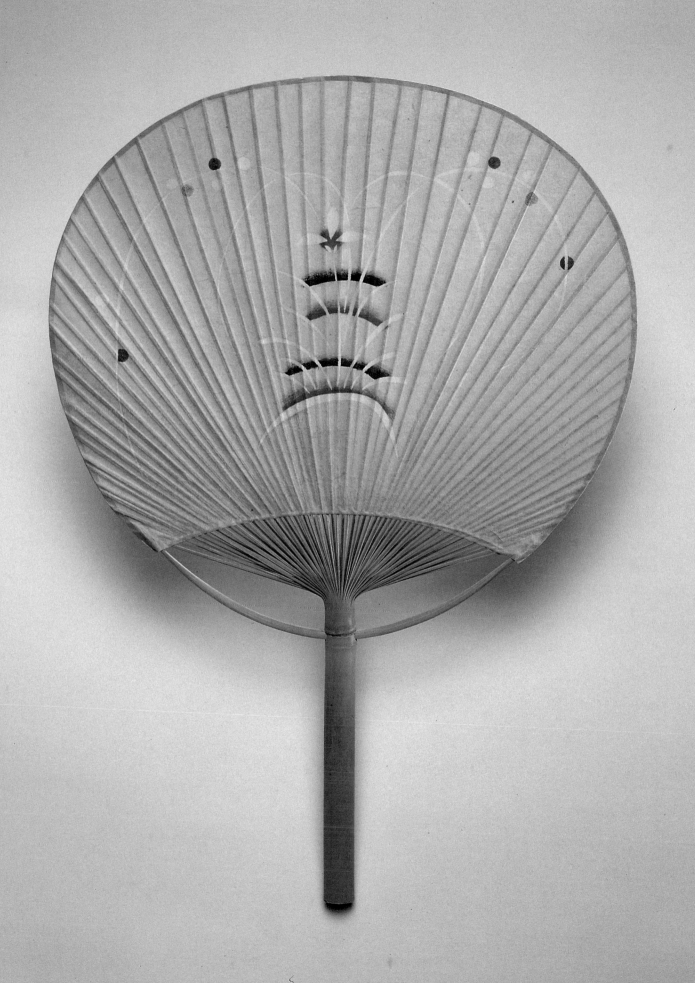

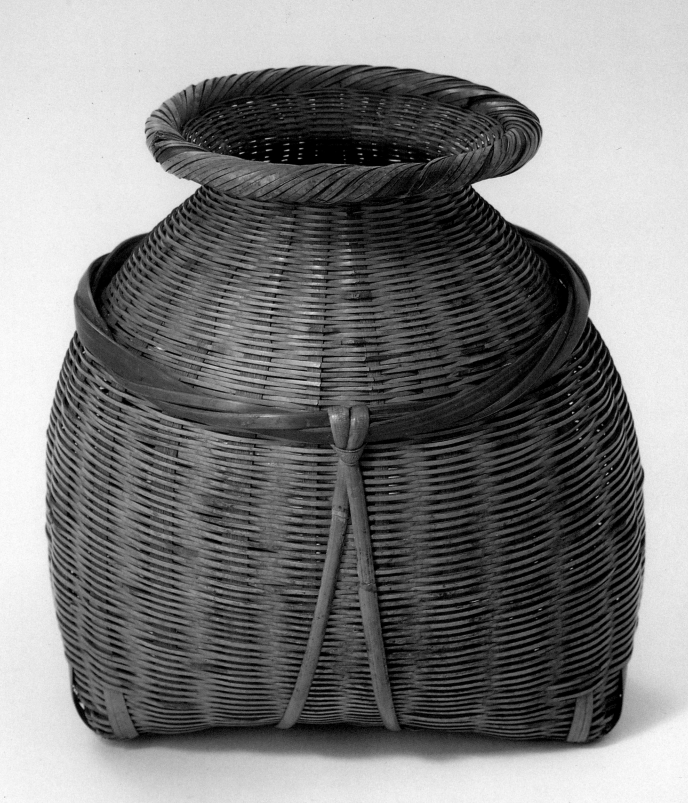

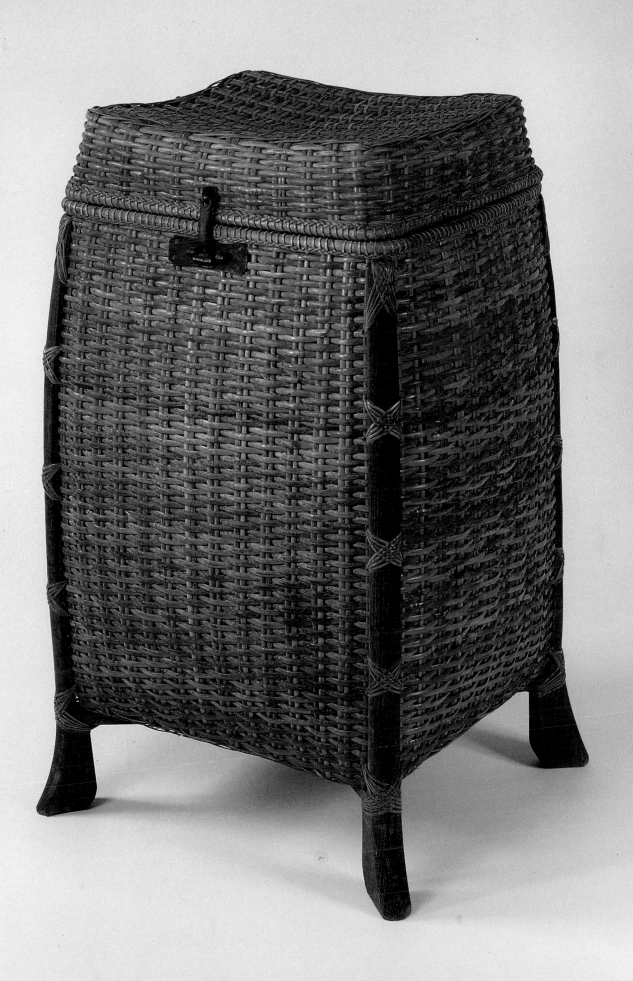

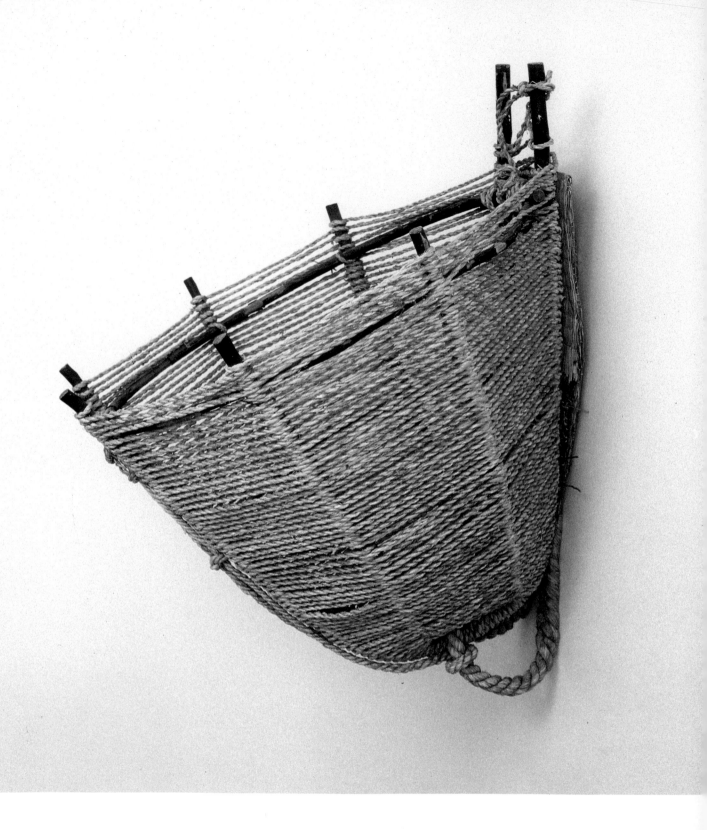

WOVEN SHOULDER PACK

Rope and wood
69.8 x 57.2cm, Japan, 20th century
Mingei International Museum

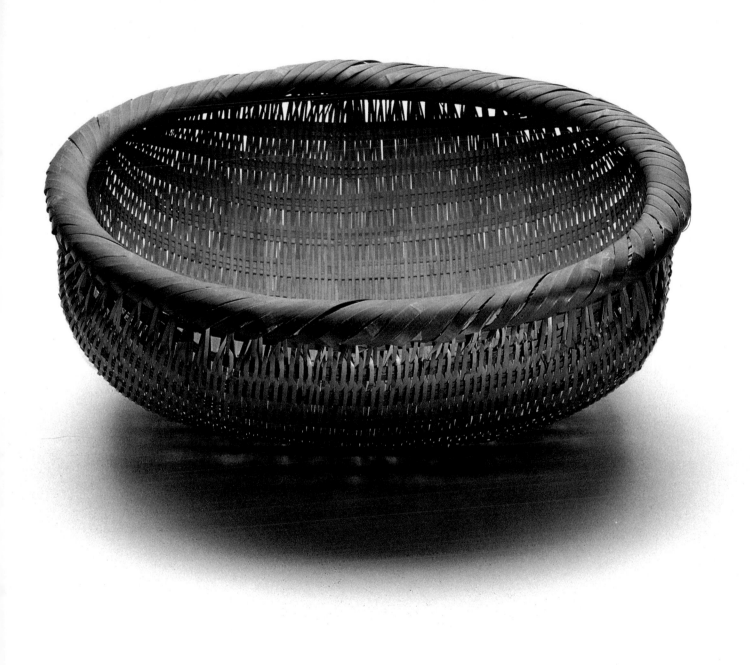

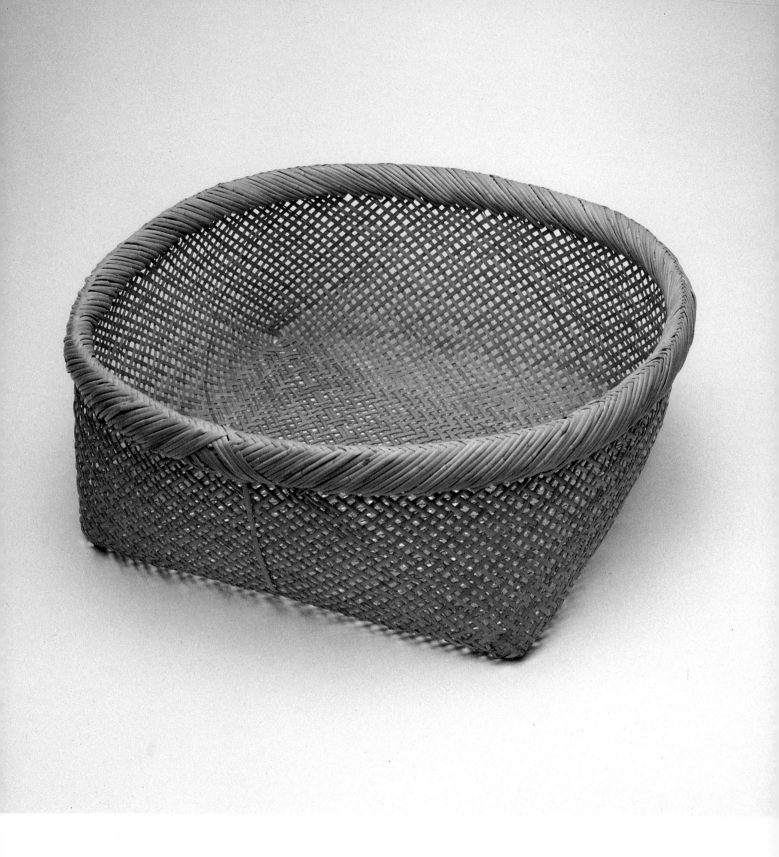

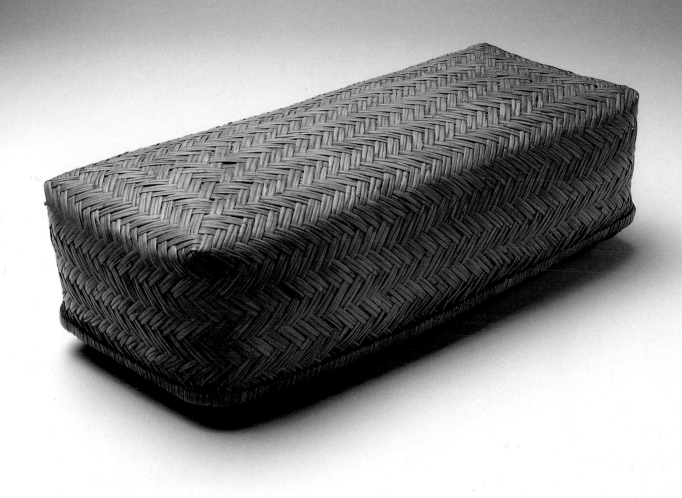

BASKET

OPPOSITE

Bamboo
16.8 x 42.2 cm top diam.
Late Shoowa Period
Attributed to Oita Prefecture, Kyuushuu
Private Collection

LIDDED BASKET

Bamboo
12 x 40.2 cm x 18.7 cm
Late Shoowa Period
Attributed to Taisho to Late Shoowa Periods
Private Collection

Lidded baskets exist in many shapes, sizes and styles and are frequently
made in nested sets for a variety of household storage needs.

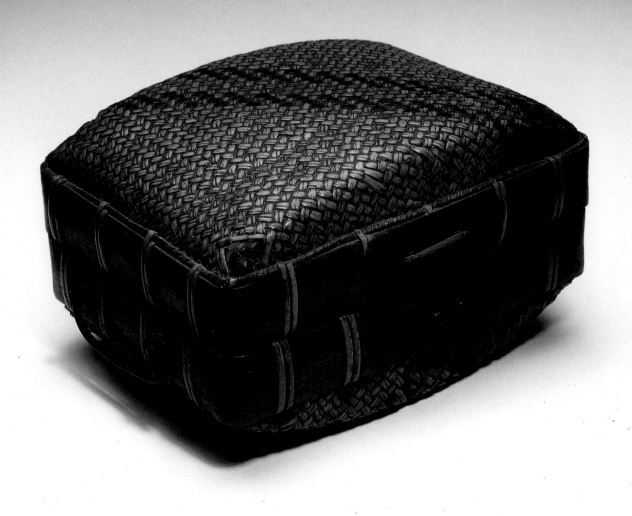

LUNCH Basket *(Obentoobako)*

Bamboo, stain, brass
Attributed to Shikoku Island, Meiji Period
9.3 x 16.5 x 12.7cm

During the Meiji Period elegant small baskets were preferred as lunch boxes during hot weather, since the baskets allowed for air circulation which prevented spoilage.

WOVEN TRAY

10.1 X 86.8cm diam.
Attributed to Taishoo to Early Shoowa Periods
Mingei International Museum 1993-54

This tray is typical of those used for feeding silkworms. Such trays, each covered with a thin mat that held silkworms and their diet of mulberry leaves, would be stacked in special open shelving.

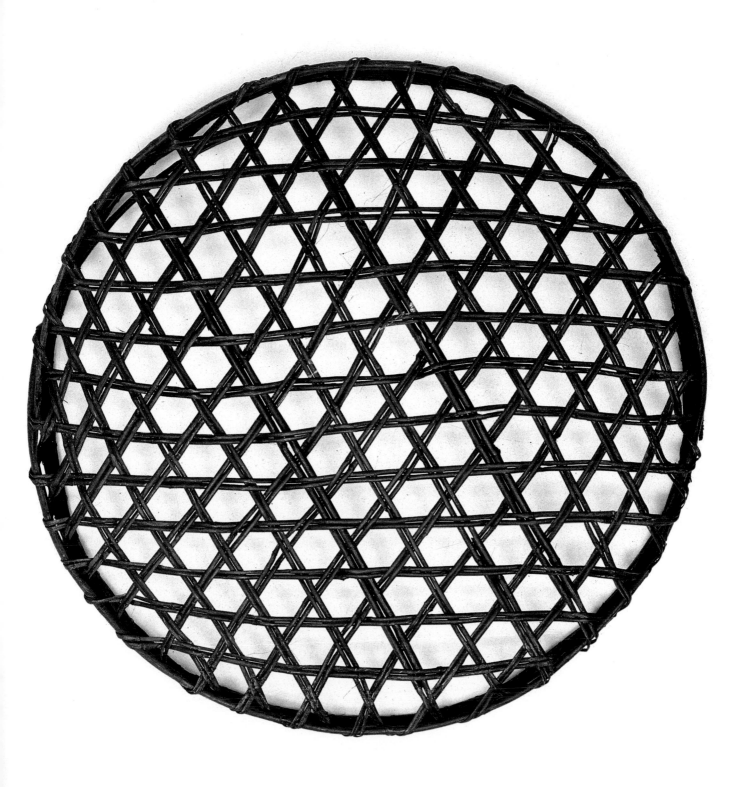

FLOWER BASKET *(Hana Kago)* OPPOSITE

Cane, lacquer, wood
27.2 x 17 cm bottom diam.
Edo to early Meiji Period not later than 1907
The Peabody Essex Museum, Salem, Massachusetts E9273

The tightly woven pattern in the body of this basket for arranging flowers gives way to an open, airy neck which flares to a flat, tightly woven rim. Four round pieces of wood are woven into the corners and form feet. The woven designs in front and back and on the four implied "corners" resemble shrimp, and have been sculpted with extraordinary skill.

FARMER'S HAT PAGE 130

Straw
15.24 x 53.3cm diam. of brim
Attributed to Nambu area, Toohoku Region, Honshuu
Private Collection

This traditional farmer's hat appears in regional festivals of Aomori and Iwate decorated with four large red pompoms.

CANOPY HAT *(Tengai)* PAGE 131

Straw
36.1 x 35.5cm diam.
Late Shoowa Period
Collection, Catherine and Lennox Tierney

Hats such as this one are reminiscent of older days when monks wore them through the countryside playing the *shakuhachi* (a mallow bamboo flute) and begging alms. In plays of the *Kabuki* theatre these hats are worn by secular characters wishing to disguise themselves.

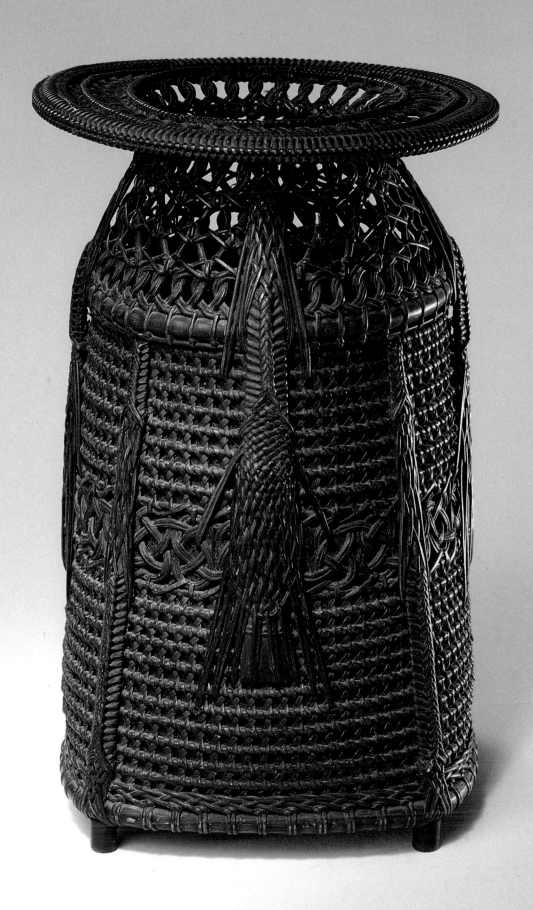

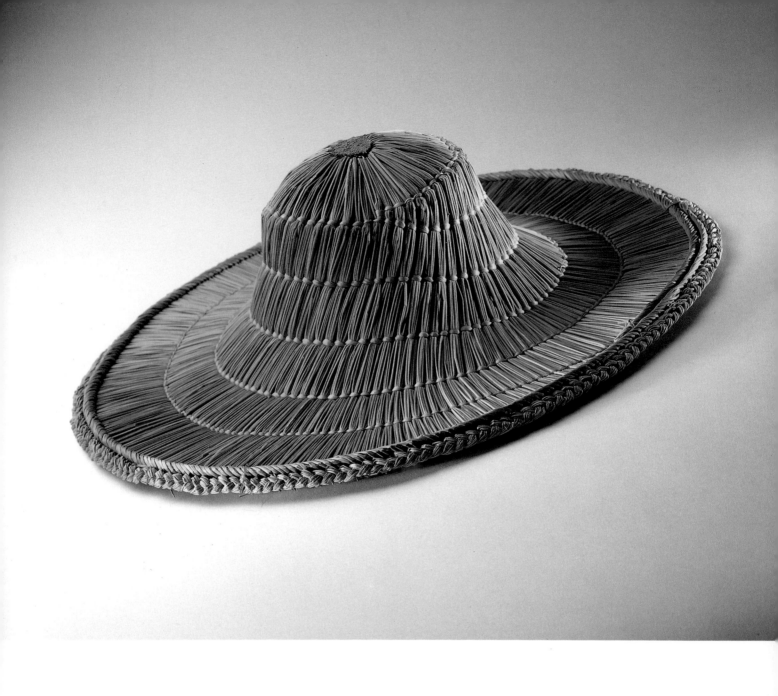

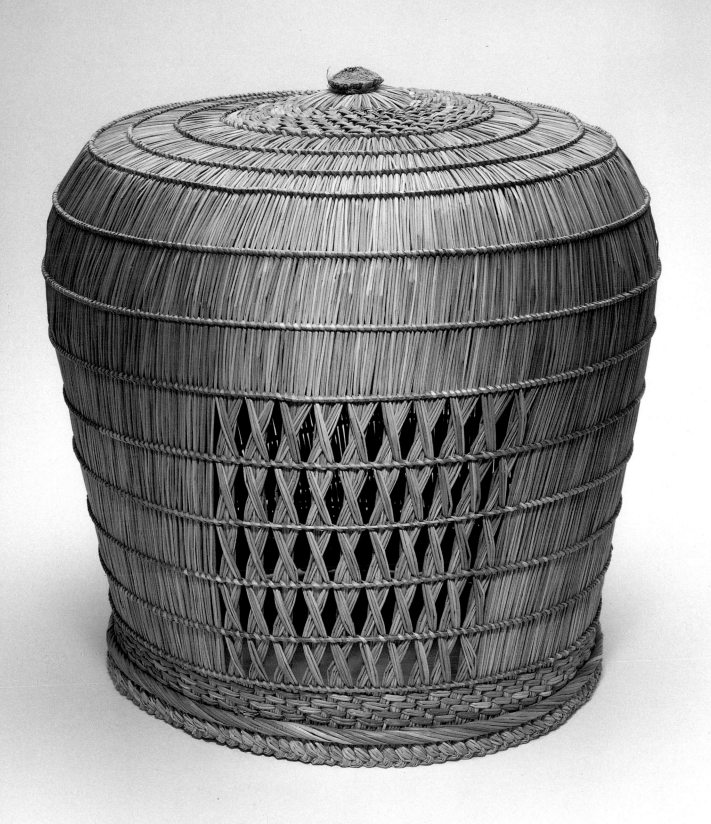

QUILTED FIREMAN'S COAT

PAGE 133

Cotton, dye, cotton thread
102 x 118.5cm
Late Edo Period
The Peabody Essex Museum, Salem, Massachusetts E10410

This quilted jacket is part of a fireman's suit and belongs to a rich tradition of Japanese clothing that is distinctive of various professions and trades. The dye-painted design on the inside illustrates some heroic episode from Japanese mythology or history in which mortals engage in fierce combat with powerful forces–not unlike that of fighting fire. A most significant image in the design is that of the dragon, which is common on firemen's clothing; for it is believed to attract water. The tiger symbolizes strength and bravery. The outside of this jacket has been resist-dyed with a pattern of masonry and either a brigade or family crest. Such jackets are made of layers of cotton that are quilted tightly in a corrugated fashion to make the garment thick enough so that it could be dampened to protect the wearer from fire.

KIMONO

PAGE 134

Keisuke Serizawa
Banana fiber *(bashoofu)*, dye
151.1 x 127 cm
Shizuoka, in Shizuoka Prefecture, Late Shoowa Period
Mingei International Museum 1993-36

The artist revived interest in regional textiles such as *asa* (hemp) and *bashoofu* (made from bast fiber of a banana indigenous to Okinawa). He created countless designs for *byoobu* (folding screens), *noren* (short doorway curtains), *(furoshiki)* carrying cloths and *kimono*, like this informal summer woman's kimono with stencilled designs of banana leaves.

Mr. Serizawa was one of the prominent leaders of the folk art movement in Japan since the early decades of the twentieth century. In 1956 his skill in stencil dyeing was designated an Important Intangible Cultural Property by the Japanese government.

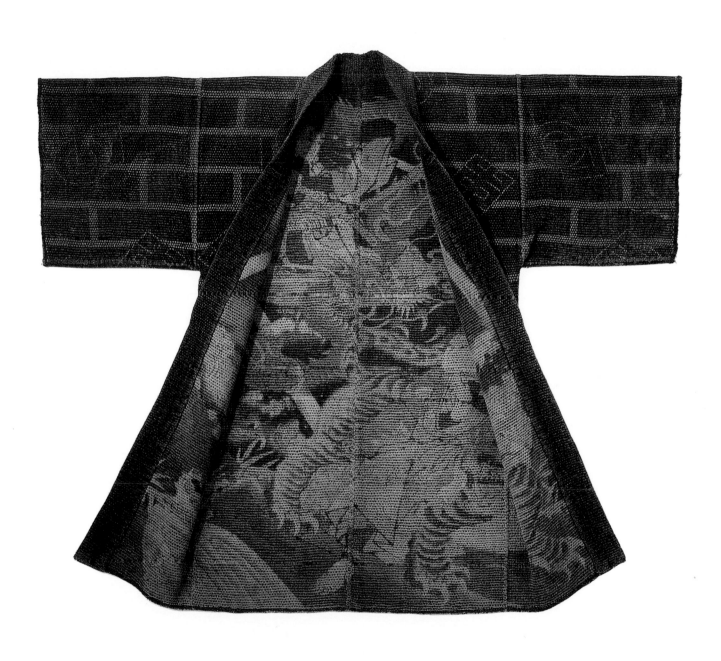

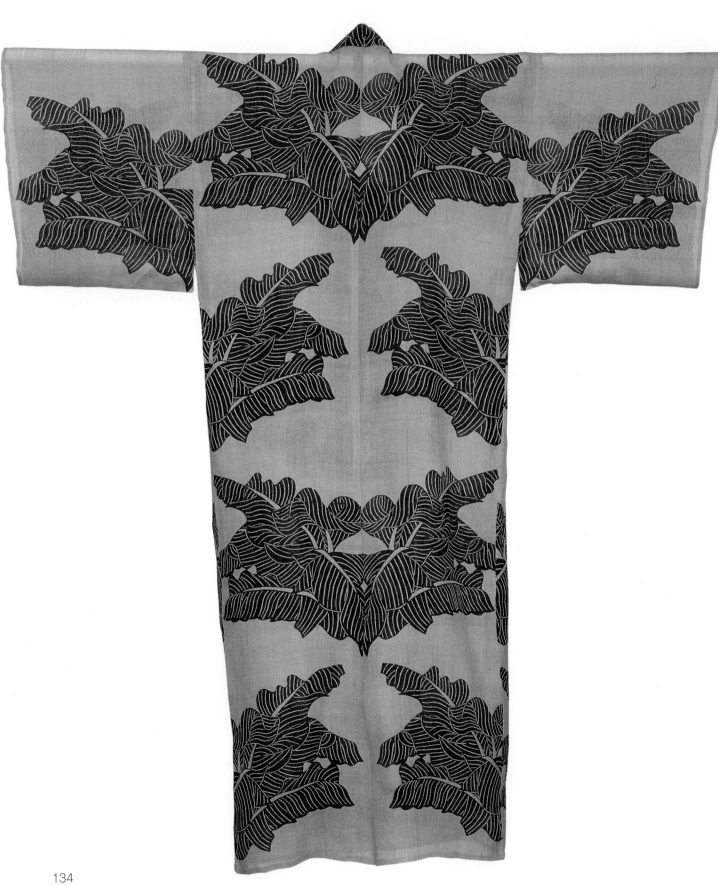

134

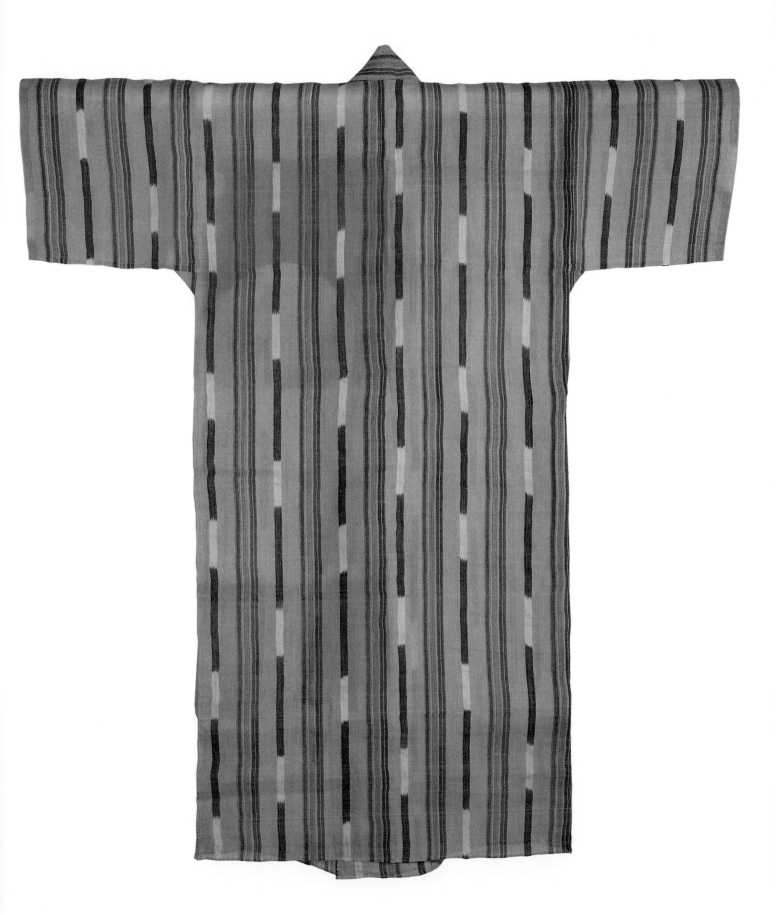

Banana bast fiber *(bashoofu)*, indigo dye
Measurements:131 x 118cm width including sleeves
Okinawa, early 20th century
The Peabody Essex Museum, Salem, Massachusetts E13748

Among the most famous of the reknowned textiles of Okinawa is fine *bashoofu*, a linen-like woven bast fiber of an indigenous banana tree. Once such weaving was common in households throughout the islands of Okinawa, but few now engage in the labor-intensive processing, splitting and weaving of the fiber. Customarily, one woman working alone would require at least six months to process enough fiber and to weave one kimono. This traditional craft has been protected by the Japanese government, and has been preserved and somewhat revived by Toshiko Taira, designated an Important Cultural Asset, and her daughter-in-law Mieko Taira. With the assistance of local women–some in their 80s and 90s, Mrs. Taira trains younger women in her studio in the small mountain village of Kijoka in the northern part of Hontoo, the largest island in the Ryuukyuuan chain. One of the most demanding skills is the splitting by fingernail of the fibers into fine threads. The non-fruiting banana trees are cut in standard but modest lengths, allowing the plant to continue to grow, thereby perpetuating the crop.

This kimono incorporates an indigo-dyed ikat *(kasuri)* within the horizontal stripes of the warp. Ikat, sometimes called "splash pattern," is accomplished by binding bundles of threads in intermittent sections to resist dyeing. In the course of the weaving, the dyed sections come together to create patterns; and this technique can be employed in either the warp or the weft and in both.

FOUR AINU PRAYER STICKS *(Iku Pashui)*

Wood, stain, lacquer
L to R: 34.9 x 3.6cm; 32.2 x 2.5cm; 32.9 x 2.8cm; 32.9 x 3.1cm
Attributed to Hokkaidoo, Late Edo to Meiji Periods
Collection, Isamu Kawaguchi

Prayer sticks were used by the Ainu to convey to their gods things of which the human voice is incapable. Each stick is given life by the carver when it is incised with three short lines called the tongue and a three-point triangle called the heart. In use the pointed end is dipped in ceremonial wine, and the human prayers are thus conveyed.

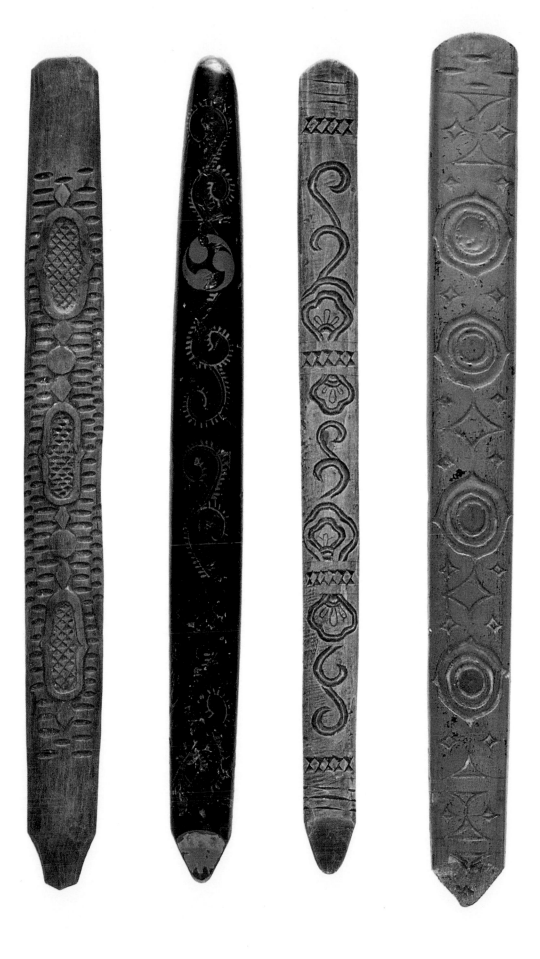

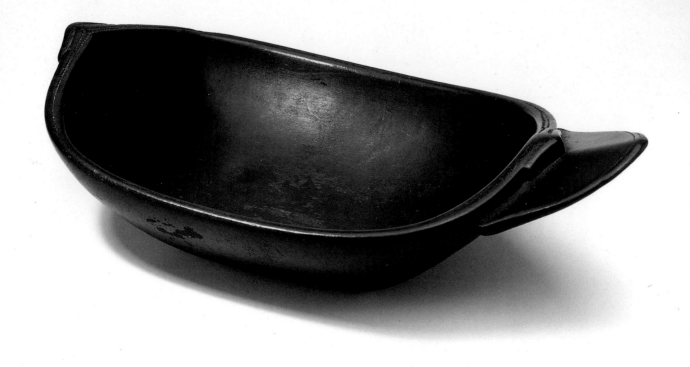

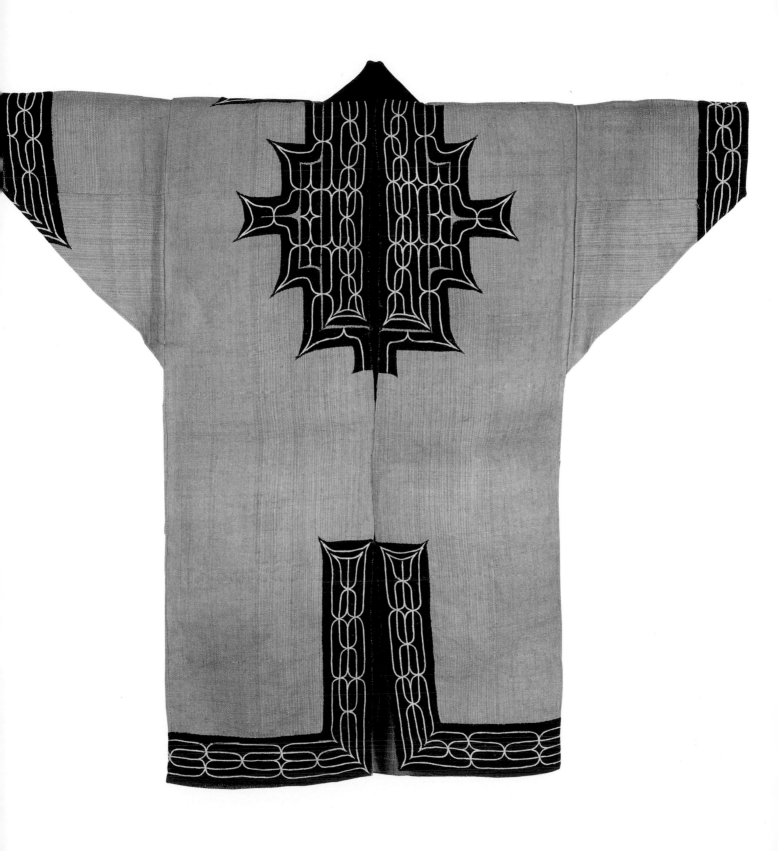

AINU WOODEN DISH *(Ki zara)* PAGE 138

Hardwood, stain
7.8 x 27.6 x 16.7 cm
Hokkaidoo or Sakalin, Late Edo–Early Meiji Periods
Mingei International Museum 1980-3-53, gift of Keisuke Serizawa

While the elaborate designs of the Ainu have attracted considerable atten-
tion, the simplicity, balance and smooth surfaces of their carved utensils
are among their finest achievements.

AINU MAN'S COAT *(Atsushi)* PAGE 139

Elm *(ohyo)* or linden *(shina)* bast fiber, cotton, indigo dye, cotton thread
124 x 130cm including sleeves
Attributed to Hokkaidoo, not later than 1916
The Peabody Essex Museum, Salem, Massachusetts E16503

The Ainu are indigenous people whose settlements once covered much of
Japan but today live mainly on the northern island of Hokkaidoo. Among
the many natural bast fibers (inner layer of trees and plant materials) they
employed in their strong textiles are elm, linden and nettle. The golden
color of this coat is natural, and one of the styles most characteristic of the
Hokkaidoo *atsushi.*

The pattern of this garment is similar to that of the standard Japanese
kimono, particularly those *atsushi* that have sleeves squared at the bottom.
The indigo cotton applique is made of Japanese trade cotton, and has
been over-embroidered in a chain stitch. The curvilinear design of the
stitching is a basic form of decoration, and can also be found carved and
incised on wooden ware and in articles woven of grass. These traditional
designs are called *morei onoka* in the Ainu language, and are translated to
mean "quietly bending." All Ainu designs are talismans and serve to pro-
tect the wearer from harm. The patterns of each robe identify the wearer's
village or family, status and sex.

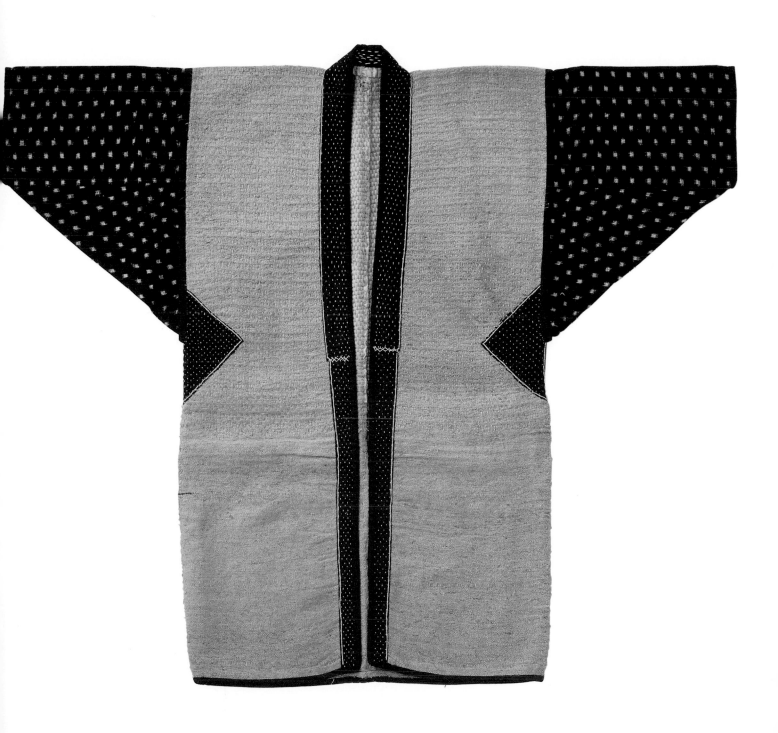

WORKCOAT *(Sakkuri)* PAGE 141

Waste hemp *(okuso)*, cotton, indigo dye, hemp *(asa)* thread
106 x 125cm
Attributed to Mikuni, in Fukui Prefecture, c.1870
Collection of Kitamaesen Museum, Kaga, in Ishikawa Prefecture
Photo: Yoshida Taddo Studio/Audrey the Design, Ltd., Tokyo.

Even though the pattern is similar to work wear, the unusual indigo cotton trim and reinforcements suggest that this coat was made for wear on special occasions. The upper half of the coat and the blue neckband have been strengthened by over-stitching well known in Japan as *sashiko,* which also makes clothing warmer.

While hemp production for marketable textiles provided cash crops for farmers in the Edo and Meiji periods, the waste hemp was woven into textiles for local use.

WOVEN RAG SASH *(Saki-ori Obi)*

Nao Maki
Cotton, cotton thread, recycled cotton rag
14 x 142cm
Tsubakizaka, in Shiga Prefecture, Shoowa Period, 1930
Collection, Dai Williams, Kyoto

Obis from the Japanese countryside, like woven rag vests and jackets, are as original as they are diverse. The finest of them show a genius in the combination and patterning of colors. Many fine *obis* are made from recycled wool and silk clothing, but those made from recycled cotton and used for work clothes in rural and coastal areas are distinctive. Woven on small, narrow looms, they often have brilliant colors and intricate patterns. Mrs. Maki made this *obi* for one of her five daughters from her children's recycled clothes. While most *saki-ori obis* are long and tied in the back in a large knot, this one has two narrow cotton ties.

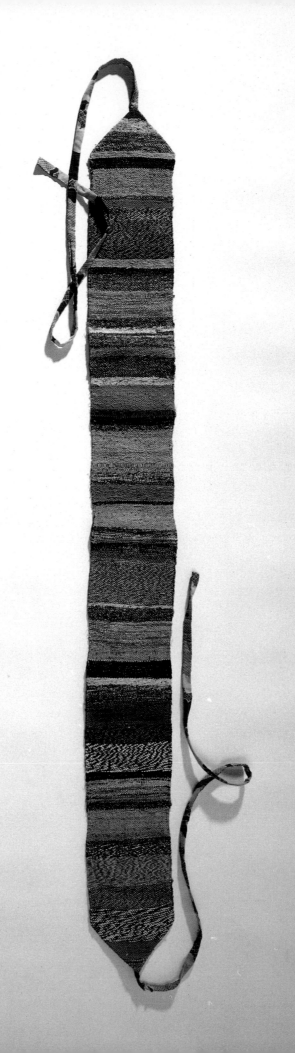

WATER BASIN *(Mizubachi)*

Glazed stoneware
24.1 x 33.6cm diam.
Futakawa Kiln, Kumamoto, in Fukuoka Prefecture, Kyuushuu
Late Edo to early Meiji Periods
Private Collection

TEA STORAGE JAR *(Chatsubo)* PAGE 146

Clay, ash glaze
37.8 x 35cm largest diam.
Seto, in Aichi Prefecture, Edo Period
The Peabody Essex Museum, Salem, Massachusetts E14289

Storage jars throughout Japan are often improvisations on a basic form according to use. This jar was made for storing dried green tea leaves. A lid was secured by cords through the ceramic loops near the neck of the jar, making it air-tight. As tea was needed, enough would be removed for immediate use, and the lid secured again. Like all utensils related to the tea ceremony, such storage jars have become highly prized as one of the most distinctive forms of Japanese ceramic art; and those from the Seto kilns are among the most refined.

Before the thrown piece dried, it was tool-marked with irregular flowing lines around the lower half; and at four places on the shoulder stylized flowers were stamped.

"HORSE EYE" PLATE *(Uma no me Zara)* PAGE 147

Glazed stoneware
4.54 x 26.6cm diam.
Seto Kiln, in modern Gifu Prefecture, Late Edo Period
Private Collection

From one of the most distinctive kilns of Japan where they were produced in vast numbers, plates like this one are prized for their freely underpainted designs.

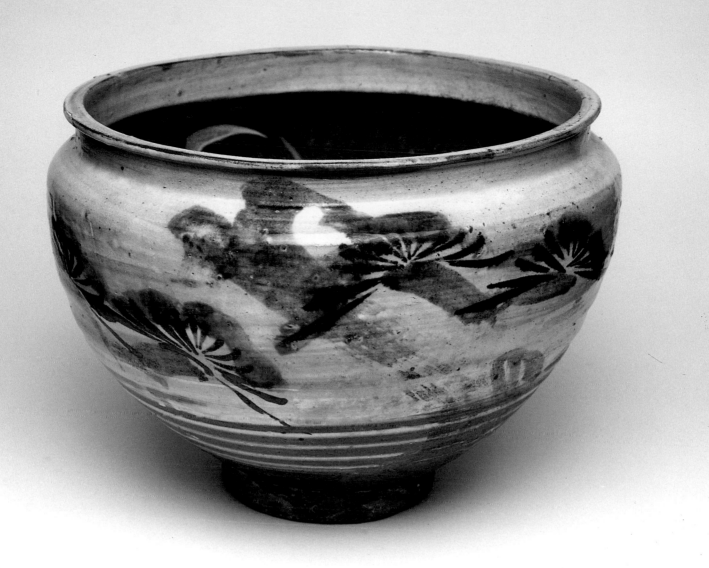

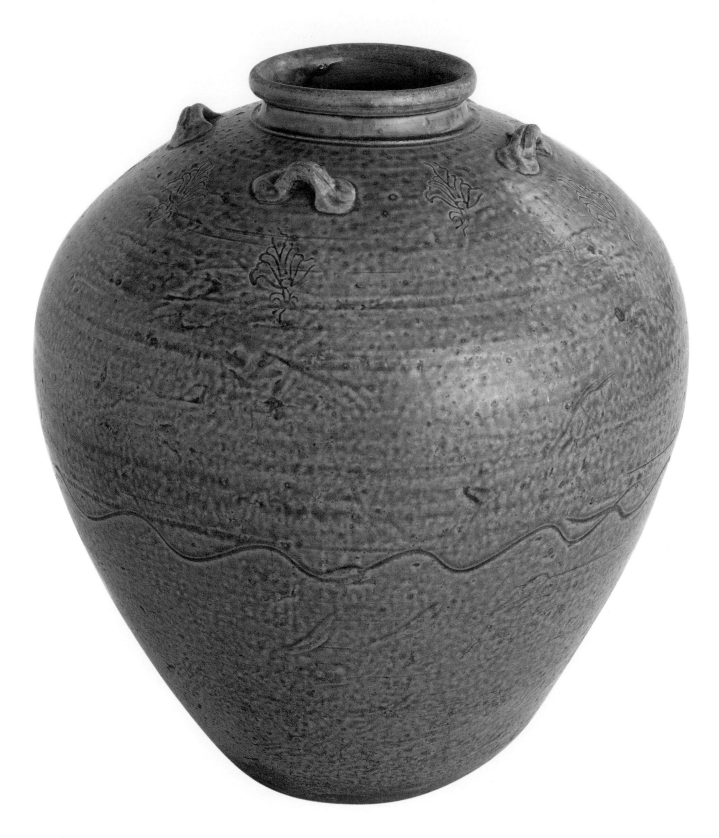

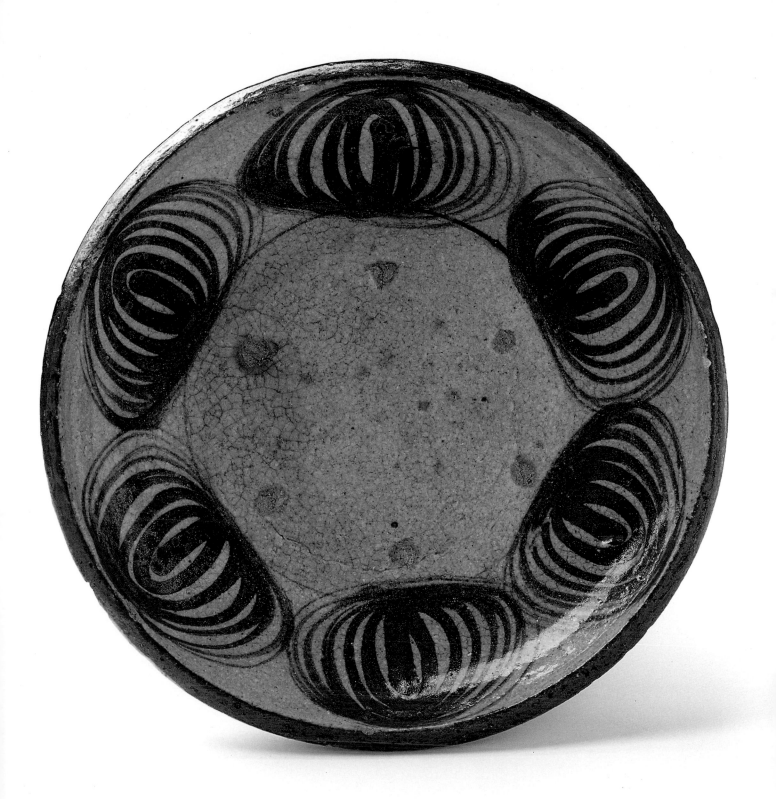

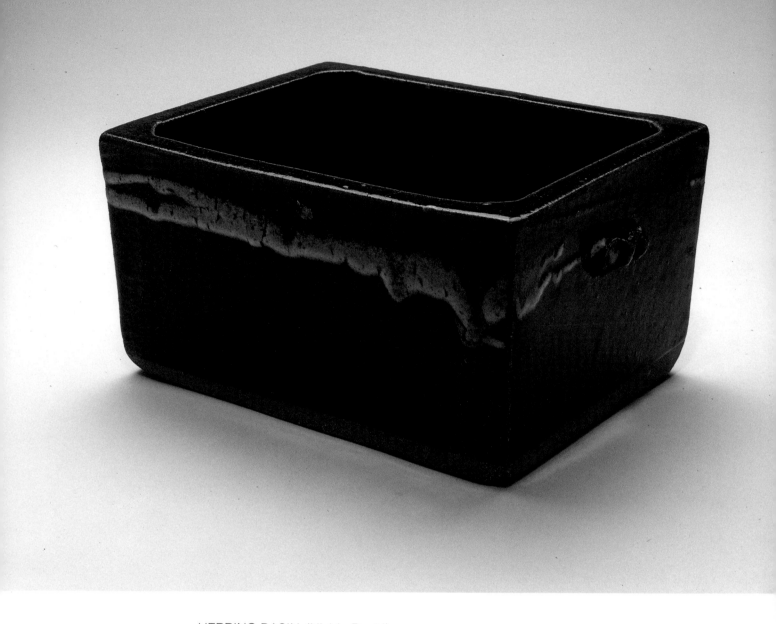

HERRING BASIN *(Nishin Bachi)*

Glazed stoneware
13.1 x 27 x 20.2c
Munakata Kiln, in Aizu-Wakamatsu, Fukushima Prefecture, Late Shoowa
Period
Private Collection

JAR

Glazed stoneware
11.4 x 13.3cm diam.
Meiji Period
Private Collection

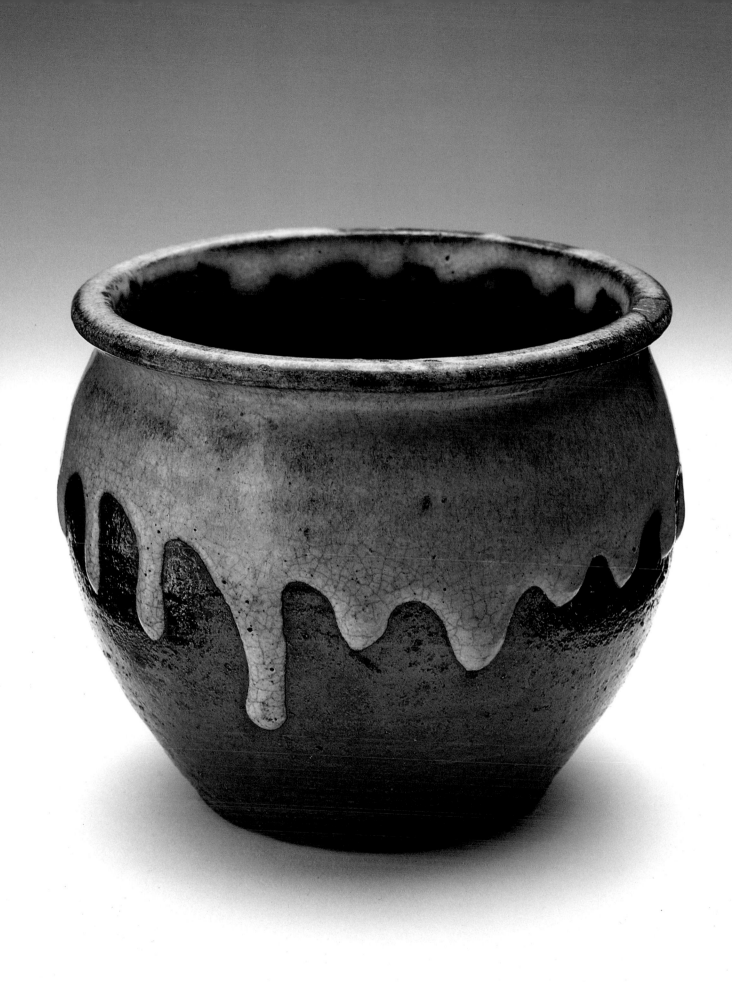

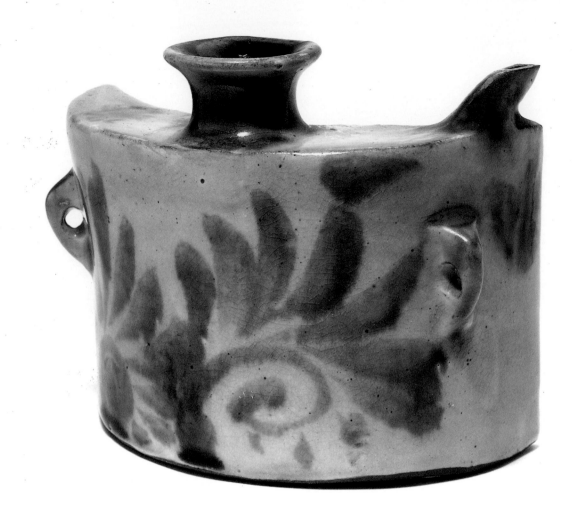

HIP FLASK *(Dachibin)*

Glazed stoneware
11.7 x 14.3 x 43.1cm
Okinawa, Mid-Shoowa Period
Collection, John and Ann Weaver

SAKE EWER *(Chuka)*

Glazed stoneware, brass
15.3 x 11.8cm diam.
Okinawa, Late Shoowa Period
Private Collection

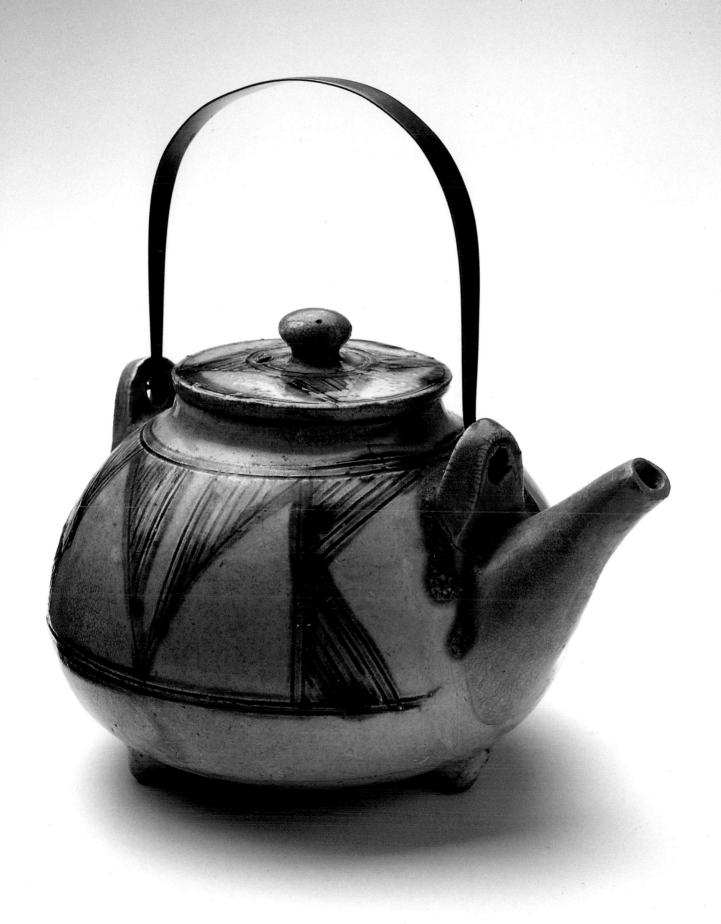

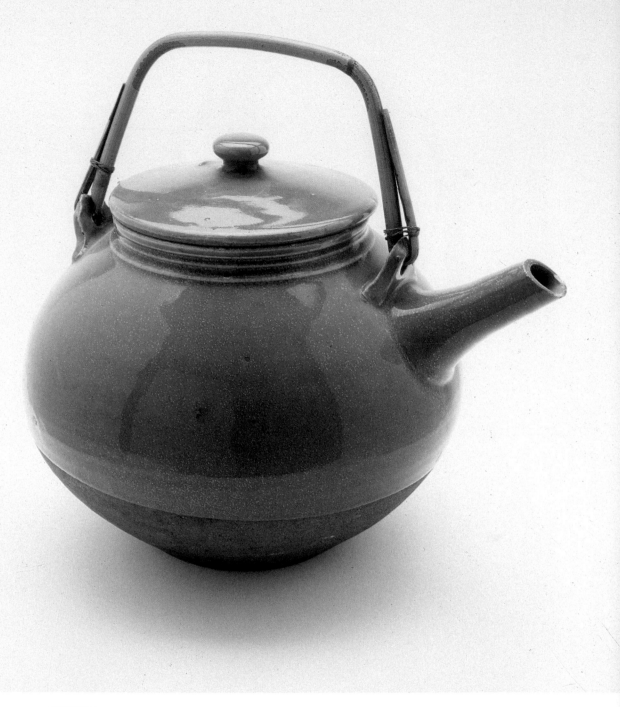

TEAPOT

Glazed stoneware, bamboo
24.4 x 21.3cm diam.
Onda Kiln, Oita Prefecture, Kyuushuu
Late Shoowa Period
Private Collection

The neighboring mountain kilns of Onda and Koishibara have produced
ceramics for more than three hundred years. They were established by
Korean potters brought to Japan in the late sixteenth century at the time of
Kideyoshi's invasions of Korea.

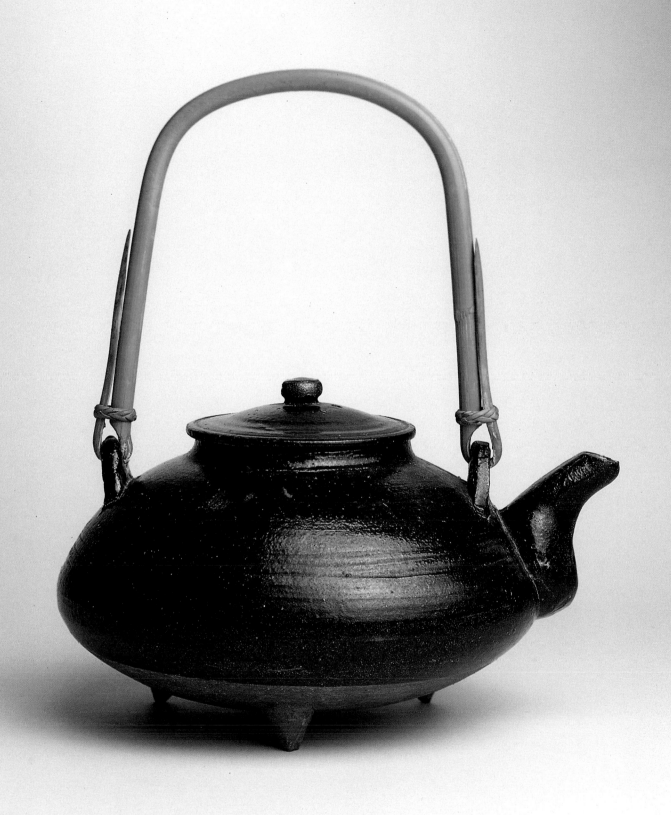

TEAPOT PAGE 153

Glazed stoneware, bamboo
27.9 x 20.3cm diam.
Naeshirogawa Kiln, Satsuma, in Kagoshima Prefecture, Kyuushuu, Late
Shoowa Period
Private Collection

Black ware for kitchen use was once made by three kilns in this part of
Kagoshima Prefecture. Only the Naeshirogawa Kiln remains active today.
Small teapots and sake ewers in this style are typical of the present
Naeshirogawa Kiln.

PLATE

Shoji Hamada
Glazed stoneware
5.7 x 26.9cm diam.
Mashiko Village, in Tochigi Prefecture, Late Shoowa Period
Private Collection

An accomplished potter, Mr. Hamada established his kiln at Mashiko which
had been a center of folk pottery. Mr. Hamada's presence and keen inter-
est in folk ceramics contributed substantially to the revival of the Mashiko
kilns. While traditional Japanese household ceramics interested him great-
ly, his own work was also strongly influenced by early Korean ceramics and
by the techniques of slip decoration advanced by his colleague, the
English potter, Bernard Leach, with whom Mr. Hamada worked in England.

The bold design of this plate is very different from the painted and
splashed glaze patterns for which Mr. Hamada is best known. The geo-
metrical pattern was created by the application of wax before the white
slip–like glaze was applied. During the firing the wax resisted the flow of
the white, eventually burning off.

For his preservation of folk pottery and its techniques, Mr. Hamada in 1955
was recognized by the Japanese government as a Holder of an Intangible
Cultural Property.

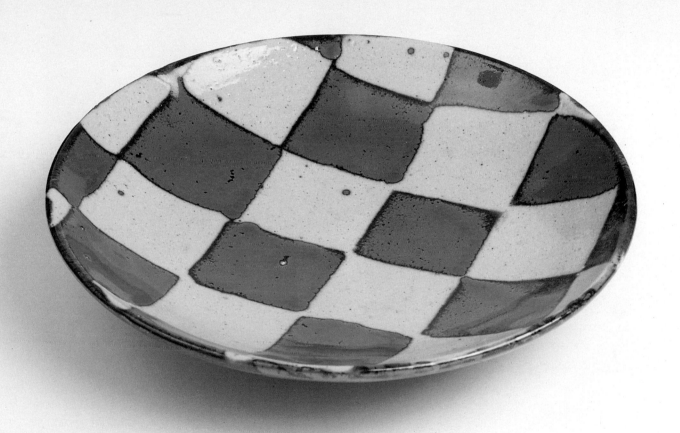

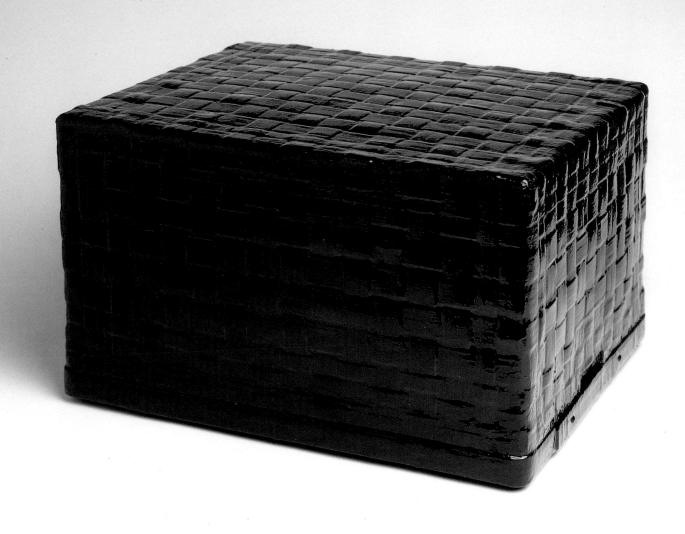

LACQUERED BAMBOO BASKET *(Hari Kago)*

Tatsuo Matsuda
Bamboo, mosquito netting, paper, persimmon tannin, varnish, lacquer
31.3 X 52.7 X 42.5cm
Kyoto, 1995
Loaned by the artist

Deep-lidded plain and lacquered baskets for storing and carrying clothes
were common in Japan until the 1940s. Tatsuo Matsuda, the fourteenth
generation head of Narakichi in the center of Kyoto, is making these bas-
kets in the same location where his ancestors made them over four hun-
dred years ago. He is the last maker of *hari kago* in Kyoto.

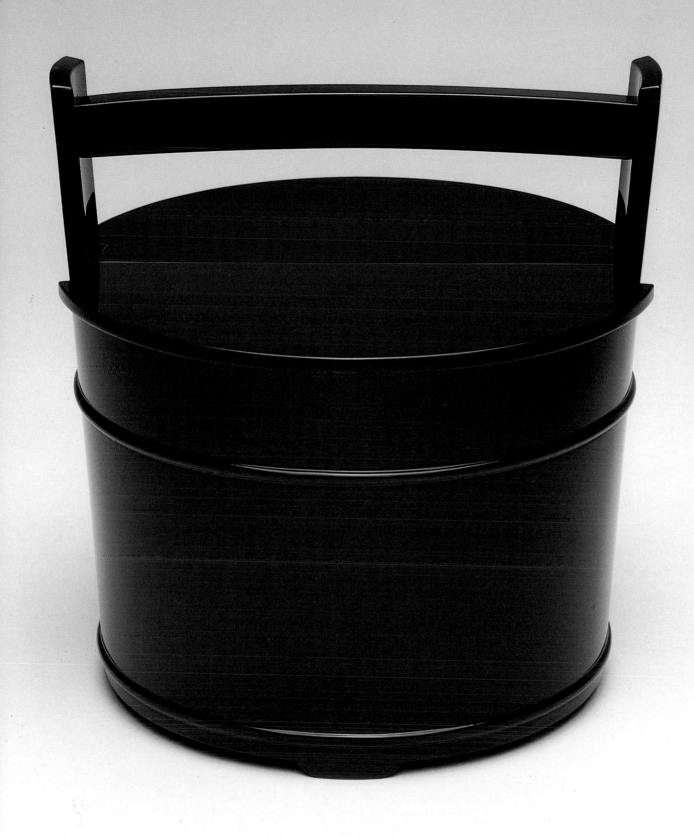

BLACK LACQUER BUCKET STYLE WATER CONTAINER
(Kuro Nuri Teoke Gata Mizuireyoki) PAGE 157

Manju Uesugi
Cypress *(hinoki),* linen, lacquer
24 x 22.5cm diam.
Kyoto, 1994
Loaned by the artist

This black lacquer fresh water container has been made for use in the formal presentation of tea, familiarly called tea ceremony. The prototype was created by the great sixteenth century tea master and founder of the modern style of tea, Sen no Rikyuu (1522-1591), who once had an ordinary bucket lacquered for use as a fresh water container. It exemplifies the trend in the sixteenth century to incorporate the aesthetics of ordinary domestic objects in tea utensils.

SAKE WARMER *(Kooshi Arare Chooshi)*

Shiko Suzuki Morihisa
Cast Iron, bronze, silver, with lattice and hailstone pattern *(kooshi arare)*
13.3 x 10cm diam.
Morioka, in Iwate Prefecture, 1995
Loaned by the artist

This small, iron kettle is made for warming the traditional Japanese wine known as *sake*. While contemporary in feeling, it combines several traditional features. The combination of the lattice and hailstone patterns is innovative. The long spout allows easy pouring into small cups. The recessed opening is a modification of a well-known design that is called *uba guchi*, ("old woman's mouth").

Suzuki Shiko Morihisa is the fifteenth generation head of Suzuki Morihisa Kooboo, one of the most reknowned traditions of iron work in the famous castle town of Morioka in the Tohoku Region. Suzuki Morihisa was founded in 1625, and in 1948 the fourteenth generation Morihisa was designated a Living National Treasure by the Japanese government. Shiiko Suzuki Morihisa has ascended to the leadership of a craft that is almost exclusively dominated by men. She has brought to traditional forms her own sensitive imagination and designs, some of which freely interpret the past.

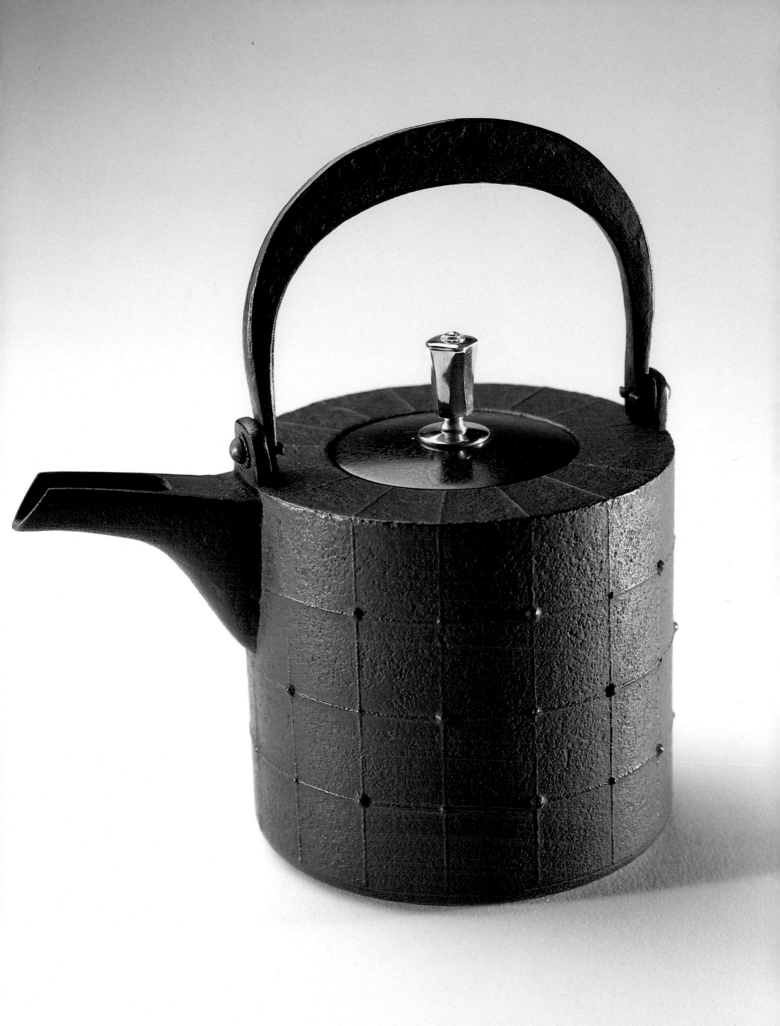

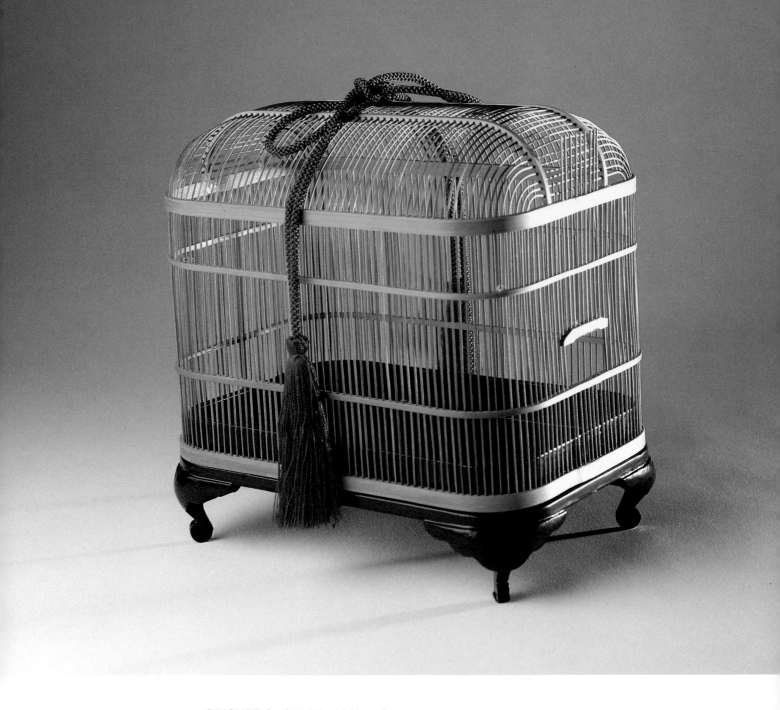

CRICKET CAGE *(Mushi Kago)*

Heiji Suzuki
Bamboo, wood, lacquer, silk, brass
22.2 x 21.9 x 15.24cm
Shizuoka, in Shizuoka Prefecture, c.1991
Loaned by the artist

Many Japanese engage in the keeping of insects which are prized for their singing. In the heat of summer, the high-pitched, rhythmic and melodious sounds of insects like the bell cricket create a cooling and restful feeling. As the weather cools in early autumn, the Japanese take their cages to a nearby grove and give the insects their long-awaited freedom.

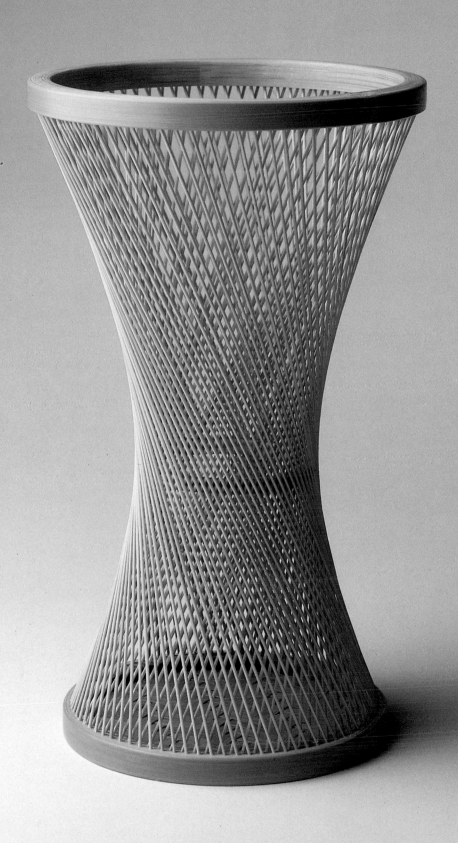

FLOWER BASKET *(Hana Kago)* PAGE 161

Shigeru Shinomiya
Bamboo
25.40 x 15.4cm top diam.
Shizuoka, in Shizuoka Prefecture, c.1994
Loaned by the artist

The Shizuoka region, between Tokyo and Kyoto, is known for its temperate climate in winter and an abundance of bamboo forests which have resulted in a rich tradition of bamboo craft. Shigeru Shinomiya is one of the region's most prominent craftsmen for bamboo work, both traditional and contemporary. He has received many honors for his designs based on a technique known as *sensuji*–(figuratively "thousand strands"), which is the splitting of bamboo strips into many fine, rounded strands for making baskets and a variety of other useful objects. Mr. Shinomiya prepares his own material and makes his pieces by hand.

The contemporary design of this container for flowers resembles the shape of a traditional Japanese drum. The construction requires precise placement of each strand in both the top and bottom rings in order to create the smooth, evenly "twisted" pattern of the surface. Because most of Mr. Shinomiya's designs place great tension on the fine strands of bamboo, they must be cut precisely with the grain and large enough to remain strong. A fitted hollow cylinder of lacquered bamboo is placed inside to serve as a container for water and flowers.

MILK HOUSE TABLE (Coffee Table)

George Nakashima
Cypress, teak, oil
44.5 x 94.6 x 87.36cm
New Hope, Pennsylvania, c.1944
Collection Mira Nakashima-Yarnall, New Hope, Pennsylvania, photo: George Erml

This table was named by Derek Ostergard when he was preparing the exhibition "George Nakashima: Full Circle," for the American Craft Museum in New York in 1989. The name derives from a small milk house on Antonin Raymond's farm in New Hope, Pennsylvania, where George Nakashima worked shortly after he had been released from an internment camp in Idaho for Japanese-Americans. It is the first in a series of his tables that focuses on form. This table is suggestive of a traditional *torii,* the symbolic entrance to Shinto shrines. Similar to low Japanese writing tables, it is designed to be taken apart. A major difference, however, is the through-tenons of the lower stretcher secured by a wedge at each end.

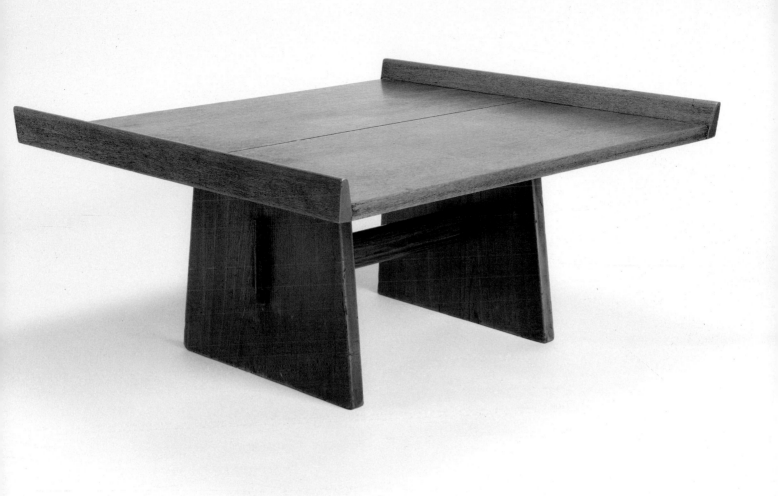

Director's Circle

Charmaine and Maurice Kaplan, Chairmen

Dr. Bernard W. Aginsky
Mrs. Frances Armstrong
Mrs. Barbara Baehr
Ms. Carolyn L. E. Benesh
Dr. & Mrs. John Bergan
Mr. and Mrs. Roy K. Black
Mrs. Sook Bower
Ms. Carole Branson
Mrs. Betty U. Buffum
Mr. & Mrs. Hugh Carter
Mr. & Mrs. Dallas Clark
Mr. Kelly C. Cole, Neiman Marcus
Mr. David Copley
Mrs. Helen K. Copley
Dr. Roger C. Cornell
Dr. Susan Crutchfield
Mr. & Mrs. Marc H. Cummings
Larry and Junko Cushman
Mr. and Mrs. Alex De Bakcsy
Mr. & Mrs. Harry De Haan
Mr. & Mrs. Michael Dessent
Dr. & Mrs. Charles C. Edwards
Mr. & Mrs. J. L. Fritzenkotter
Mr. & Mrs. John Gilchrist
Joyce and Edward Glazer
Mrs. Connie Golden
Dr. & Mrs. Hugh Greenway
Jean Hahn
Mr. & Mrs. Bruce Heap
Mrs. Joan Holter
Alan and Nora Jaffe

Mrs. Louisa Kassler
Mr. Maurice M. Kawashima
Mr. & Mrs. James Kerr
Mrs. Helen W. Korman
Mr. Armand Labbe
Dr. & Mrs. Don Leiffer
Mr. Robert K. Liu
Dr. Stefan Max
Mr. & Mrs. George M. Pardee
Dr. and Mrs. Stanford S. Penner
Mrs. Betty Jo Petersen
Diane Powers
Mr. and Mrs. Sol Price
Mr. Elliott Rabin
Ms. Elizabeth Riis
RADM & Mrs. W. Haley Rogers, USN (Ret)
Niki de Saint Phalle
Dr. and Mrs. Greg Semerdjian
Dr. Robert Singer & Ms. Judith Harris
Mr. Bradley Smith
Mr. & Mrs. Worley Stewart
Mrs. Rosamond Swanson
Mr. & Mrs. Horton Telford
Mr. & Mrs. John M. Thornton
Dr. and Mrs. Kenneth Trefftzs
Mrs. Barbara Walbridge
Mr. & Mrs. Frank Warren
Mr. and Mrs. Albert N. Williams
Mr. & Mrs. Harold B. Williams
Dr. Richard P. Wunder
Mr. & Mrs. Walter J. Zable

Patrons

Mrs. Willoughby Bishop
Ms. Margaret Cargill
Dr. and Mrs. Kirk J. David
Philip D. Davidson/Bonita Roche
Mrs. Merie Davis
Mrs. Audrey Geisel

Mrs. Milton D. Goldberg
Mr. William E. Heyler
Mr. and Mrs. Kenneth E. Hill
Mrs. Ellen Revelle Eckis
Mr. Tatsuzo Shimaoka
Mr. and Mrs. Bob Sinclair

Museum Staff

MARTHA W. LONGENECKER	Founding Director
JAMES R. PAHL	Deputy Director
CAROL Z. KLICH	Executive Secretary/Office Manager
ROB SIDNER	Public Relations and Membership Director
JOHN P. DIGESARE	Registrar/Education Coordinator
RESHMA J. SOLBACH	Museum Store Manager
ANN V. PEDICORD	Museum Store Assistant
BRYAN J. LOYCE	Security Guard

VOLUNTEER STAFF

NANCY J. ANDREWS	Librarian
VIRGINIA PANIONE	Volunteer Coordinator
EILEEN MILLER	Coordinator-Receptions
V'ANN CORNELIUS	Docent Coordinator
JAKE HARSHBARGER	Registration Assistant
BILLIE SUTHERLAND	Secretary

WILLIAM THRASHER **EXHIBITION GUEST CURATOR**

EXHIBITION DOCUMENTARY PUBLICATION

DESIGN AND EDITING	Martha W. Longenecker
DEVELOPMENT	James R. Pahl
ASSISTANT EDITOR	Rob Sidner
PRODUCTION ASSISTANT	Reshma J. Solbach
REGISTRATION	John P. Digesare
PHOTOGRAPHY (except as noted)	Shaker Objects - Paul Rocheleau
	Japanese Objects - Lynton Gardiner
TYPESETTING	Karen Crampton
SEPARATIONS AND PRINTING	Diversified Color Systems/PrintPro, Hong Kong

MINGEI INTERNATIONAL, Inc., a non-profit, public foundation is supported by memberships, volunteer services and tax deductible donations. Membership is open to all those interested in furthering the understanding of world folk art.

MINGEI INTERNATIONAL MUSEUM OF WORLD FOLK ART IS ACCREDITED BY THE AMERICAN ASSOCIATION OF MUSEUMS. FOR INFORMATION (619) 453-5300.

FOLLOWING PAGE: JAPANESE CANDLEMAKER'S SHOP SIGN – Zelkova *(keyaki)*, traces of black lacquer, iron, 61 x 22.4 cm., Edo Period. The Peabody Essex Museum, Salem., Massachusetts. E21772.

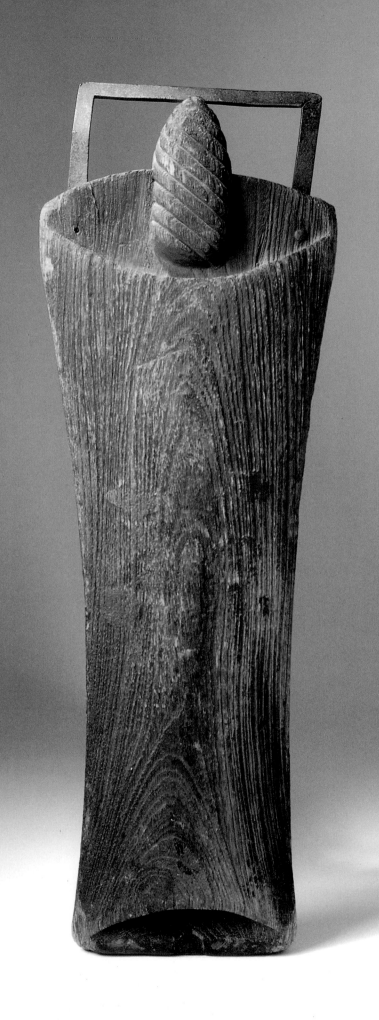